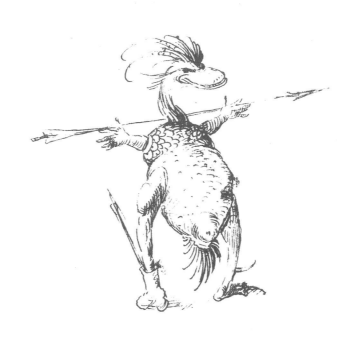

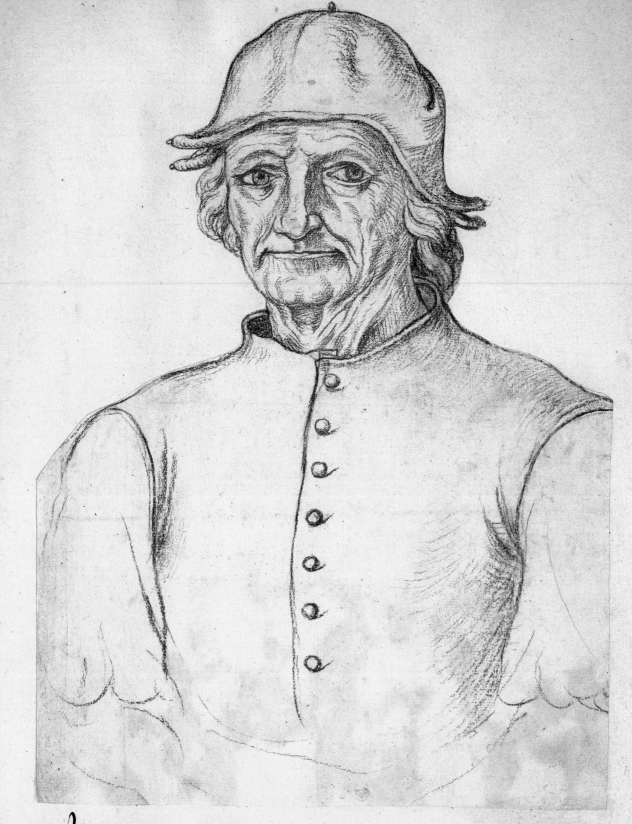

Jeronimus Bos painter

Walter Bosing

HIERONYMUS BOSCH

c. 1450–1516

Between Heaven and Hell

TASCHEN

To stay informed about upcoming TASCHEN titles,
please request our magazine at www.taschen.com/magazine or write to
TASCHEN America, 6671 Sunset Boulevard, Los Angeles, CA 90028, USA;
contact-us@taschen.com; Fax: +1-323-463-4442.
We will be happy to send you a free copy of our magazine,
which is filled with information about all of our books.

© 2012 TASCHEN GmbH
Hohenzollernring 53, D–50672 Köln
www.taschen.com

Original edition: © 1987 Benedikt Taschen Verlag GmbH
© 1973 for the text by Thames & Hudson Ltd., London
Edited by Ingo F. Walther
Text revised and amended by Norbert Wolf, Munich
Cover design: Catinka Keul, Angelika Taschen, Cologne

Printed in Germany
ISBN 9783-8228-5856-1

Contents

Introduction

The pictorial world of Hieronymus Bosch, so strange to the modern viewer, is best studied in the Museo del Prado in Madrid. Here, in one of the upper galleries, are gathered no less than three major altarpieces and several smaller pictures by Bosch and his workshop. They present a dramatic contrast to the other Netherlandish paintings hanging in the room. The coolly observed and precisely rendered details of the *Betrothal of the Virgin* (c. 1440), attributed to a master in the circle of Robert Campin, and the solemn, sculptural figures of the *Descent from the Cross* painted around 1430 by Campin or his pupil Rogier van der Weyden (or possibly as a collaboration between the two), have nothing in common with the devil-infested landscapes of Bosch's *Haywain* or his *Garden of Earthly Delights*. The older masters anchored their subjects in the realm of empirical visual experience, even when treating supernatural themes. Bosch, on the other hand, seems to confront us with a world of dreams, and more specifically a world of nightmares, full of ghosts rising like insistent hallucinations.

Bosch's pictures have always fascinated viewers, albeit often for ambivalent reasons. In the earliest and furthermore highly reliable account of Bosch's art, recorded around 1560, the Spaniard Felipe de Guevara* noted that Bosch only painted "monsters and chimeras" when the subject demanded it, but that these were understood by his countless imitators, as "comical things". The Dutch writer on art Carel van Mander**, writing some 50 years later, correspondingly qualified Bosch's paintings chiefly as "wondrous and strange fantasies". These "fantasies" were evidently placed in the same category as drolleries, the fantastical, witty, farcical motifs that bordered the pages of late medieval manuscripts, and as the *grotteschi* of Italian Renaissance ornament. In Italy, Bosch's bizarre composite figures were known at that time as *grilli*, "whims" or "fancies", unleashed from a world of wild imagination and harmless quirkiness.

This earlier tendency towards a "light-heartening" of Bosch may astonish many readers, considering that modern authors, in particular those of the first half of the twentieth century, have positively surpassed themselves in their efforts to offer an ever more profound interpretation of Bosch's art. Some exegetes have gone so far as to "decipher" a secret language of Rosicrucianism, alchemy, astrology and Jewish Gnosticism in Bosch's subjects. Other writers have seen him as a sort of fifteenth-century Surrealist who, in the manner of a Salvador Dalí, dredged up his disturbing forms from the depths of his subconscious, perhaps even under the influence of mind-altering drugs. Most far-reaching – and most fateful in terms of Bosch scholarship – have been the attempts to connect the artist with the various religious heresies that existed during the Middle Ages. Mention must be

The Tree Man
Pen and bistre, 27.7 x 21.1 cm
Vienna, Albertina

* Felipe de Guevara: *Commentarios de la pintura*, ed. A. Ponz, Madrid 1788.

** Carel van Mander: *The Lives of the Illustrious Netherlandish and German Artists*, ed. Hessel Miedema, trans. Derry Cook Radmore, Doornspijk 1996.

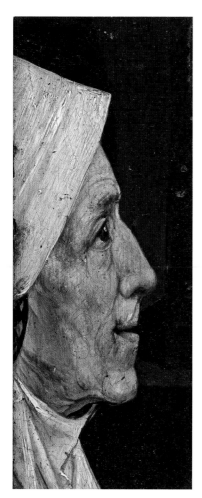

Hieronymus Bosch (?)
Head of a Woman (fragment)
Oil on panel, 13 x 5 cm
Rotterdam, Museum Boijmans Van Beuningen

* Wilhelm Fraenger: *The Millennium of Hieronymus Bosch: Outlines of a New Interpretation*, trans. E. Wilkins and E. Kaiser, Chicago 1951, London 1952.

** Norman O. Brown: *Love's Body*, New York 1966.

*** Dirk Bax: *Hieronymus Bosch: His Picture-writing Deciphered*, trans. M. A. Bax-Botha, Rotterdam 1979.

**** Roger H. Marijnissen: *Hieronymus Bosch: The Complete Works*, trans. T. Alkins, Antwerp 1987.

made first and foremost here of the thesis proposed by Wilhelm Fraenger*. Fraenger claimed that Bosch was a member of the Brethren of the Free Spirit, a sect that flourished throughout half of Europe for several hundred years after its first appearance in the thirteenth century. It is supposed that its members practised sexual promiscuity as part of their religious rites, through which they attempted to achieve the state of innocence possessed by Adam before the Fall; hence they were also called Adamites. Fraenger believed that Bosch intended his most famous triptych (one of the most reproduced works of European art history, by the way), the *Garden of Earthly Delights* (pp. 54–55), for a group of Adamites in 's-Hertogenbosch, where Bosch himself lived, and that the unabashedly erotic scene of the central panel represents not a condemnation of unbridled sensuality, as is generally believed, but the religious practices of the sect. Fraenger also linked other works by Bosch to the Adamites and their doctrines.

For a time Fraenger's thesis acted like a problem-solving wonder drug both for Bosch scholarship at institutes of higher learning and for the sensational appetites of certain audiences. In his book *Love's Body* of 1966, one advocate of what might be called "therapeutic sexuality", Norman O. Brown**, cited Bosch's *Garden of Earthly Delights* as an illustration of his own theories put into practice.

Fraenger's constructions are nowadays rejected almost without exception as scholarly nonsense. We have no historical evidence that Bosch was ever a member of the Adamites or that he painted for them. In fact, the last certain reference to this group in the Netherlands appears in Brussels in 1411. But even if the Adamites survived somehow undetected into the early sixteenth century, Bosch himself can hardly have been anything other than an orthodox Christian. Not without reason did the painter belong – like his father and brothers – to the Brotherhood of Our Lady, a guild of clergy and laity devoted to the Virgin Mary whose members were free of all suspicion of heresy. Bosch executed several official commissions for this confraternity. His position as a sworn brother would have been predicated upon his first receiving minor orders and exercising a low-ranking ecclesiastical office, something difficult to imagine in the case of an artist heretic. Bosch furthermore enjoyed the patronage of highly placed members of the Church and nobility, one of whom, Hendrik III of Nassau (1483–1538), in all probability also commissioned the *Garden of Earthly Delights*. The religious othodoxy of these patrons can scarcely be doubted. After the middle of the sixteenth century, a number of Bosch's works – including the same *Garden of Earthly Delights* – were acquired by the most conservative Catholic of them all, Philip II of Spain. And this during the Counter-Reformation, when fanatical Inquisitors kept a particularly dogmatic watch on matters relating to Christian doctrine. Isolated accusations that Bosch's paintings were "tainted with heresy" were only heard in Spain towards the end of the sixteenth century, but were soundly refuted by the Spanish priest Fray José de Sigüenza in 1605.

Rather than getting lost in endless speculation, it is far more appropriate to consider Bosch in terms of the folklore and historical context of his day and to identify as one of his sources of inspiration the moralizing proverbs and songs that were in widespread circulation at that time. As the Netherlandish and Belgian scholars Dirk Bax*** and Roger H. Marijnissen****, in

particular, have shown, Bosch's paintings often house visual translations of verbal puns and metaphors. Nor should we forget the criticism – long voiced in art and lent renewed expression in many media as the Middle Ages gave way to the Renaissance – of the corrupt state of the official Church and of the arrogance, greed and sexual dissoluteness of the clergy. Bosch was no less confronted by this than by the raging excesses of superstition, which articulated themselves above all in the fear of witchcraft, in witchhunts and witch burnings.

The interpretation of Bosch's works – the relevant literature has today grown to well over 1,000 titles – is made more difficult by the fact that virtually none of his paintings can be confirmed as autograph. Meanwhile, many of the works from which earlier art historians have drawn bold conclusions have now been classified as paintings by pupils, as replicas or as paraphrases. And of the fewer than twenty drawings attributed to Bosch to date, only three (a figure that is perhaps a little too purist) are currently considered absolutely genuine, namely the *Nest of Owls* in Rotterdam (p. 58), *The Tree Man* in Vienna (p. 6) and *The Hearing Forest and the Seeing Field* in Berlin (p. 53). But even the the remaining sheets – executed by Bosch's workshop, pupils and close imitators – also represent something entirely new in Netherlandish draughtsmanship in their concentration upon profane, farcical and demonic motifs. The identification of Bosch's authentic pictorial inventions is further complicated by the countless copies of his paintings by other hands – a good thirty replicas of the Lisbon altarpiece (pp. 92–95) are known from the sixteenth century alone. The enduring difficulty of judging a Bosch drawing on the basis of stylistic criteria is illustrated by the Dresden *Virgin and St John at the Foot of the Cross* (p. 76). Whereas some scholars in the past were able to imagine it might be a brush drawing by Bosch, it is today dated to around 1440 and attributed to an anonymous Netherlandish or possibly even Austrian artist.

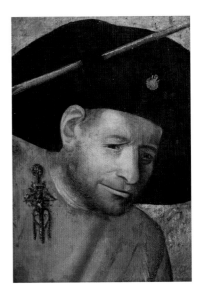

Imitator of Hieronymus Bosch (?)
Head of a Halberdier
Oil on panel, 28 x 20 cm
Madrid, Museo del Prado

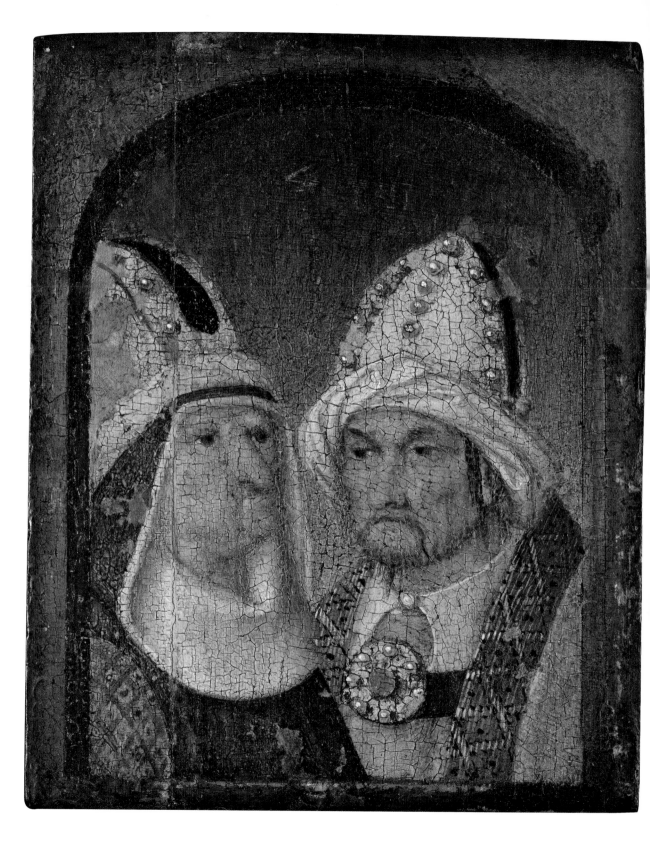

Life and Milieu

Hieronymus Bosch lived and worked in 's-Hertogenbosch, the city that he evidently chose to adopt as his own surname. In Bosch's day, 's-Hertogenbosch was one of the four largest communes of the duchy of Brabant, which belonged in turn to the duchy of Burgundy. The other chief Brabantine cities, Brussels, Antwerp and Louvain, lay further south, in what is now Belgium, whereas the more northerly 's-Hertogenbosch was situated close to the provinces of Holland and Utrecht and the Rhine and Meuse rivers. In the late Middle Ages, 's-Hertogenbosch was a thriving commercial town, the centre of an agricultural region, and maintained extensive trade connections both with northern Europe and with Italy. Although its cloth industry was important, the city was especially famous for its organ builders and bell founders. It was also an important centre of knife manufacture, as witnessed by a detail on the *Hell* wing of the *Garden of Earthly Delights* (p. 54). The blade of the huge knife in the top left-hand corner, between the pair of ears, carries an uncial M that has inspired countless, often abstruse interpretations. An archaeological find in s'Hertogenbosch has since revealed that the M in fact represents the actual master's mark of a local cutler.

The predominantly middle-class commercial population determined much of the city's character, for 's-Hertogenbosch had no ducal court, nor was it the seat of a university or a bishopric like Brabant's other major communes. Bosch's native city nevertheless boasted a Latin school and several literary circles.

It was also home to numerous religious communities and activities: a great number of convents and monasteries were situated in and around the city. Of special interest are the two houses established by the Brothers and Sisters of the Common Life. A modified religious order without vows, this brotherhood was founded in Holland in the late fourteenth century in an attempt to return to a simpler and more personal form of religion, which was called the *Devotio moderna*. Its character is well exemplified in the famous devotional treatise generally attributed to Thomas à Kempis, the *Imitatio Christi,* or *Imitation of Christ*, which, as we shall see, must have been well known to Bosch and his patrons. The *Devotio moderna* played an important role in the religious revival of the fifteenth century and probably contributed to the extraordinary increase in the number of religious foundations in 's-Hertogenbosch. Indeed, by 1526, just ten years after Bosch's death, one out of every nineteen persons in 's-Hertogenbosch belonged to a religious order – proportionally many more, in other words, than in other Netherlandish cities of the same epoch. The presence of so many cloisters and the economic competition they represented seem to have fuelled considerable hostility amongst the townspeople – and these disputes, too, were reflected in Bosch's art.

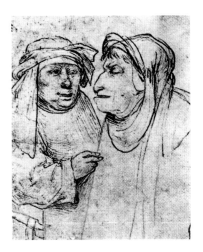

Workshop
Two Heads
Pen and bistre, 13.3 x 10 cm
New York, Lehmann Collection

Anonymous southern Netherlandish master
Two Figures with Mitres, 15th cent. (formerly
attributed to Bosch)
Oil on panel, 14.5 x 12 cm
Rotterdam, Museum Boijmans Van Beuningen

On the whole, however, the authority of the Church had not yet been seriously shaken and religion still permeated all aspects of everyday life. Each guild had its own patron saint, and every citizen participated in the major feasts of the Church and in the annual religious processions. The great church of St John (Sint Jan) presented itself then as now as a stone embodiment of faith and as a testimony to the civic pride and commercial prosperity of the city. Begun in the late fourteenth century and only completed in the sixteenth (in 1559 the parish church was elevated to the status of cathedral), it is an impressive masterpiece of Brabantine Gothic, noteworthy for its wealth of carved decoration. In particular amongst its rows of fantastical figures, amongst the goblins and monsters sitting astride the buttresses, some authors have wished to see inspiration for the creatures of Bosch.

The church of St John was in the early phases of construction when Bosch's ancestors settled in 's-Hertogenbosch in the late fourteenth or early fifteenth century. Their family name, van Aken (van Aaken, van Aeken, van Acken), suggests that they originally came from the German town of Aachen. The first certain reference to the family dates from 1430/31 and relates to Bosch's grandfather, Jan van Aken, who died in 1454. Jan had five sons, at least four of whom were painters; one of these, Anthonius van Aken, who died around 1480, was the father of Hieronymus Bosch.

Bosch left no diaries or letters. What we know of his life and artistic activity must be gleaned chiefly from the brief references to him in the municipal records of 's-Hertogenbosch and especially in the account books of the Brotherhood of Our Lady. These records, to be sure, tell us nothing about the man himself and give us not even the date of his birth. A portrait of the artist, perhaps the copy of a self-portrait, shows Bosch at a fairly advanced age (p. 2). On the assumption that the original was done shortly before his death in 1516, it has been supposed that he was born around 1450 (some authors firmly accept the year 1453). Bosch is first mentioned in municipal records in 1474, where he is named along with his two brothers and a sister; one brother, Goossen (d. 1497), was also a painter. Some time between 1479 and 1481, Bosch married Aleyt Goyaerts van den Meervenne (d. 1522/23). Probably some years his senior, she came from a good family and had considerable wealth of her own.

In 1486/87, Bosch's name appears for the first time in the membership lists of the Brotherhood of Our Lady. Founded some time before 1318, the Brotherhood comprised both lay and religious men and women whose devotions were centred on a famous miracle-working image of the Virgin, the *Zoete Lieve Vrouw*, enshrined in St John's. This large and wealthy organization, whose members were drawn not only from 's-Hertogenbosch but from all over the northern Netherlands, the Rhineland and Westphalia, played a dominant role in the city's religious and cultural life. Singers, organists and composers supplied music for the Brotherhood's daily masses and solemn feasts. The Brotherhood also commissioned works of art to embellish the chapel of Our Lady, and in 1478 they decided to construct a new and more splendid chapel, attached to the north side of the unfinished choir of St John's.

Most of the members of the van Aken family belonged to the Brotherhood, and a number of them carried out tasks of an artistic nature on its behalf. Thus they were frequently entrusted with the gilding and polychrome

Copy (?)
Adoration of the Magi (Epiphany), c. 1518 or later
Oil on panel, 74 x 54 cm
Philadelphia, Philadelphia Museum of Art
The John G. Johnson Collection

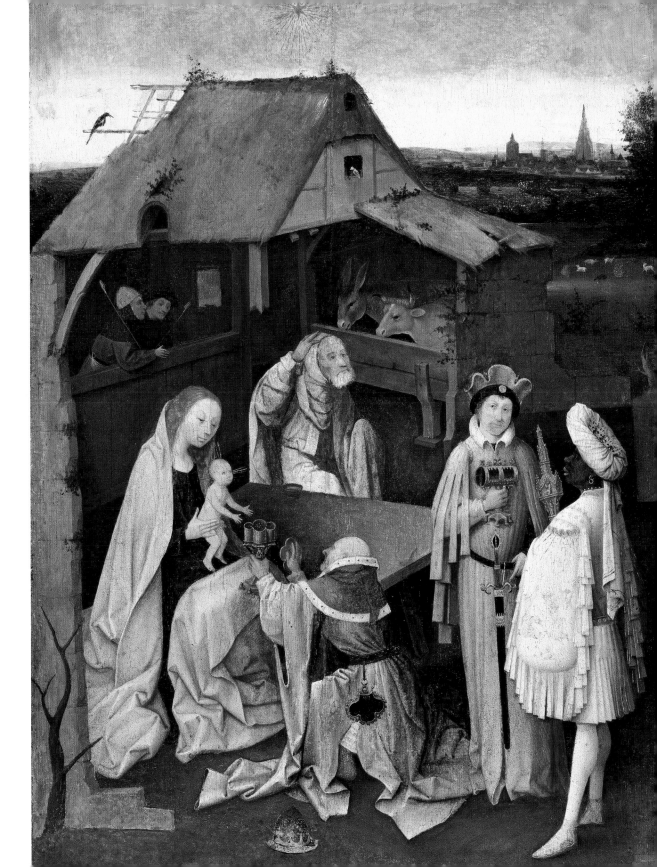

Bosch or his workshop
Study for an *Ecce Homo*
Pen, 12.4 x 12.6 cm
New York, Pierpont Morgan Library

Ecce Homo
(Christ Presented to the People), c. 1476 or later
Oil on panel, 75 x 61 cm
Frankfurt am Main, Städel Museum

* Gerd Unverfehrt is particularly critical of a
large number of attributions, supporting his
views with convincing arguments in:
*Hieronymus Bosch: Die Rezeption seiner Kunst im
frühen 16. Jahrhundert*, Berlin 1980; Fritz Koreny
probably overshot the target at the Bosch
conference in Rotterdam on 6 November 2001,
when he excluded from Bosch's oeuvre amongst
other works the *Haywain* triptych in the Prado,
the *Wayfarer [The Prodigal Son]* in Rotterdam,
the *Paris Ship of Fools*, the Vienna *Christ
Carrying the Cross*, the Lisbon *St Anthony*
altarpiece and all the panels in Venice.
Important publications of recent years include
Jos Koldeweij, Paul Vandenbroeck and Bernard
Vermet: *Hieronymus Bosch: The Complete
Paintings and Drawings*, New York 2001, and
Larry Silver: *Hieronymus Bosch*, New York 2006.

** For this reason, the only dates proposed in
the captions in this book are those that seem
fairly consistent and are accepted by the
majority of Bosch scholars.

painting of the wooden statues carried in the annual processions. Bosch's father, Anthonius van Aken, seems also to have acted as a sort of artistic adviser to the Brotherhood. In 1475/76, for example, he and his son were present when the Deans of the Brotherhood discussed the commission of a large wooden altarpiece, completed in 1477 for their chapel.

Hieronymus's name only appears in the records of the Brotherhood as from 1480/81. From this point in time onwards, he received a number of commissions from it. These included several designs, one in 1493/94 for a stained-glass window in the new chapel, another in 1511/12 for a crucifix and a third in 1512/13 for a chandelier for the choir of St John's.

There is no documentary evidence that Bosch ever left his home town. Certain aspects of his early work nevertheless suggest a sojourn in Utrecht, and the influence of Flemish art on his mature style indicates that he may also have travelled in the southern Netherlands. Bosch also did not necessarily paint his *Crucifixion of a Female Martyr* (p. 84) in northern Italy, where the cult of St Julia – if she is indeed the female martyr iconographically intended – was especially popular. He could equally well have received the commission from Italian merchants or diplomats residing in the Netherlands, as was the case with the famous Portinari altarpiece (c. 1475–1479; Florence, Galleria degli Uffizi) by Hugo van der Goes.

One final entry in the accounts of the Brotherhood of Our Lady records Bosch's death in 1516; on 9 August of that year, a funeral Mass was celebrated in his memory in the church of St John.

There are only a few other historical references to Bosch's works. From several seventeenth-century sources we learn that other paintings by him were to be seen in St John's church. In 1504, Philip the Handsome, Duke of Burgundy, commissioned an altarpiece from "Jeronimus van Aeken called Bosch" – the first time, incidentally, that the painter was referred to by his birthplace. The altarpiece was to depict the *Last Judgement* flanked by *Heaven* and *Hell*. This work is lost, but some scholars believe that a glimpse of it survives in a fragment now housed in Munich (pp. 42–43), while others identify the Last Judgement triptych in Vienna (p. 39) as a smaller-scale replica by Bosch of Philip's altarpiece. Neither suggestion is entirely convincing. Of the paintings attributed to Bosch in the public and private collections of Europe and the United States and, more specifically, considered to be autograph (a number that totals some thirty, twenty-five or even fewer, depending on expert opinion*), we cannot be sure when any of them were produced. Not one is dated, and some have been so heavily damaged and overpainted that it is impossible to draw any reliable conclusions from them. The datings that have been put forward in the literature, at times extremely controversial and diverging by decades, prove that, in the absence of archival material, the tools of stylistic criticism are insufficient to construct a proper chronology.**

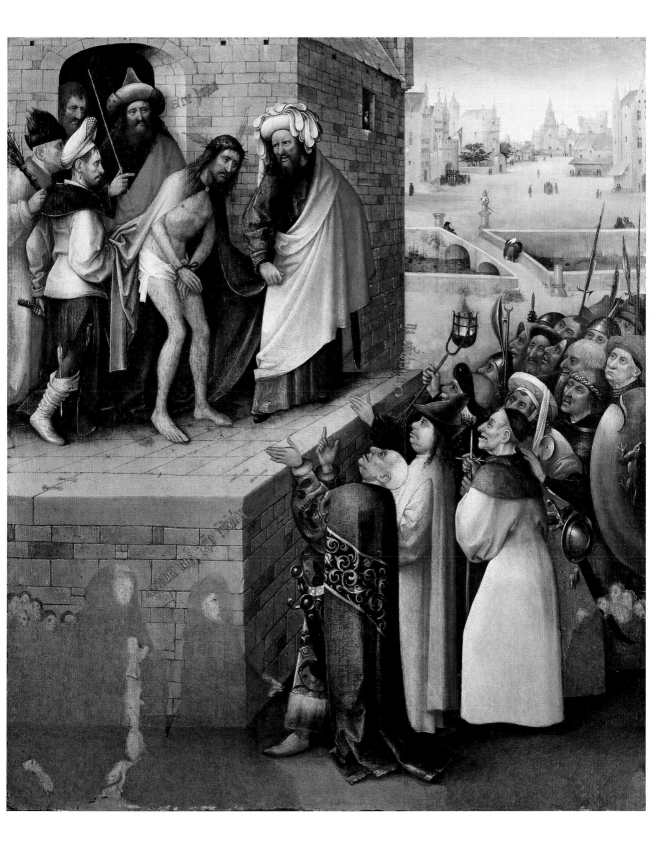

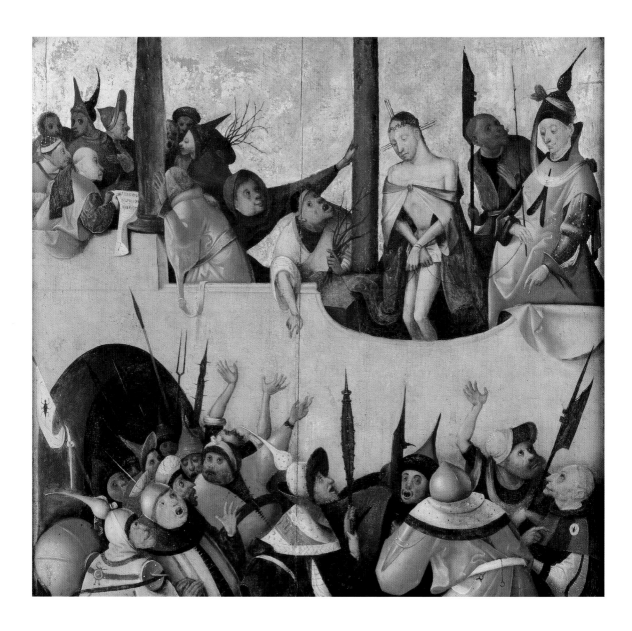

Artistic Origins and Early Biblical Scenes

If we know little about Bosch's life, we know even less about his artistic background. It is generally assumed that he was trained by his father or one of his uncles. By the time he began producing his own independent works, the first great masters of the Flemish school, Jan van Eyck and Robert Campin, had been dead some thirty years. Rogier van der Weyden had also died, but his cool and restrained art was continued, somewhat ineptly, by his followers in Brussels; it had also profoundly influenced Dirk Bouts, now at the end of his career in Louvain, and Hans Memling in Bruges. A more independent style was emerging in the powerful compositions of Hugo van der Goes in Ghent.

During Bosch's lifetime, the northern provinces of the Netherlands were neither as wealthy nor as politically powerful as Brabant and Flanders. Nevertheless, it is evident that a fairly significant school of painting existed at Haarlem under Geertgen tot Sint Jans and his followers, while the anonymous Master of the Virgo inter Virgines worked in Delft during the last two decades of the fifteenth century. Although only a few panel paintings can be connected with Utrecht, this ancient city seems to have been an important centre of manuscript illumination. Did Bosch perhaps complete his training under a book painter and absorb influences from this sphere?

Because 's-Hertogenbosch was a part of Brabant and the church of St John represents the high point of Brabantine Gothic, many writers have sought the origins of Bosch's art in the traditions established by Robert Campin, Rogier van der Weyden and other artists who worked in the southern Netherlands. Others again, on the other hand, have either utterly denied all evidence of these links or accepted them only in the case of later works. Bosch's early and middle works – insofar as we may justly speak of such within a chronology that is only relative – display more affinities with Dutch art, however, and particularly with its manuscript illumination. Dutch miniatures have been cited as sources of inspiration for the Philadelphia *Adoration of the Magi* discussed below and for the Berlin *St John the Evangelist on Patmos* (p. 89).

In principle, Bosch's art cannot clearly be assigned to any "school". It remains unique not only in its iconography but also in its style and technique. Its oft-vaunted realism applies to the psychological portrayal of the actors, not (or not so much) to the accurate reproduction of objects and their material surfaces. The priming of his panels is substantially thinner than that of other Early Netherlandish artists, so that in paler areas the structure of the wood grain shines through. Nor did Bosch lay down his paint in multiple layers, but wielded his brush in a considerably more spontaneous, "gesticulatory", painterly manner. In places, he even used a palette knife or rubbed individual areas of paint with his finger. And with his virtuoso gradation of

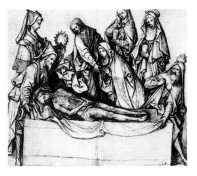

Follower of Hieronymus Bosch
The Entombment
Brush and black and grey ink with grey wash, over a preliminary drawing in black chalk,
25 x 35 cm
London, The British Museum, Department of Prints and Drawings

PAGE 16:
Ecce Homo
(Christ Presented to the People)
Oil on panel, 52 x 53.9 cm
Philadelphia, Philadelphia Museum of Art
The John G. Johnson Collection

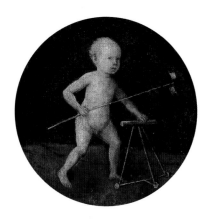

Christ Child with a Walking Frame
Tondo on the reverse of *Christ Carrying the Cross*
Oil on panel, diameter approx. 28 cm
Vienna, Kunsthistorisches Museum

colour zones to convey a sense of depth through aerial perspective, in particular in his landscape backgrounds, he achieved an incomparable effect when measured against the other Netherlandish artists of the fifteenth and sixteenth century.

Among the works that are ascribed by many, although by no means all, to Bosch's first period of activity, are several small biblical scenes: the *Adoration of the Magi* in Philadelphia, now frequently judged a copy (p. 13), the *Ecce Homo* in Frankfurt am Main (p. 15), which on the basis of current scholarship and recent scientific analysis of the painting is today considered probably the only autograph work from the artist's early years, and an altarpiece wing in Vienna showing *Christ Carrying the Cross* (p. 19), which a number of art historians prefer to date to Bosch's middle period, however. All of these panels adhere to a relatively simple and conventional compositional type.

In the charming *Adoration of the Magi* in Philadelphia, the dignified comportment of the kings is contrasted with the impulsive gesture of the Christ Child and the "genre figure" of the elderly Joseph, who stands discreetly to one side, removing his hood as if abashed by the presence of the splendidly dressed strangers. From behind the shed, two shepherds look on with shy curiosity. At this early date, Bosch's grasp of perspective was apparently none too firm; particularly ambiguous is the spatial relationship of the stable to the figures in the foreground, although the crumbling walls and thatched roof have been painted with a loving attention to detail. The high vanishing point, the diagonal angle of the stable and the panoramic landscape in the distance could be derived from works by Robert Campin or miniatures from the first third of the fifteenth century.

In contrast to the intimate, almost cosy atmosphere of this *Adoration of the Magi*, the Frankfurt *Ecce Homo* conveys the relentless brutality of this scene from the Passion (p. 15). Crowned with thorns and his flesh beaten raw by the scourge, Christ now stands with Pilate and his companions before the angry mob. The dialogue between Pilate and the crowd is indicated by the Gothic inscriptions, which function not unlike the balloons in a modern comic strip. From the mouth of Pilate issue the words "Ecce Homo" (Behold the Man). There is no need to decipher the inscription "Crufige Eum" (Crucify Him), the cry which rises from the people below; their animosity is unmistakably conveyed by their facial expressions and threatening gestures. The third inscription, "Salve nos Christe redemptor" (Save us, Christ Redeemer), once emerged from the male donor figures in the lower left-hand corner, who were painted over at a later date, probably in the seventeenth century (as were the female donor figures in the bottom right-hand corner). As with the Magi in the Philadelphia *Adoration*, the heathen character of the men surrounding Christ is suggested by their strange dress and headgear, including pseudo-oriental turbans. The depraved and plebeian nature of the agitated crowd is lent expression in faces whose features are exaggerated to the point of caricature and distorted into hideous grimaces – an artistic device typically employed in those days to brand Jews, for example. This pejorative basic tenor is underscored by the presence of traditional emblems of evil, such as the owl in the niche above Pilate and the giant toad – an animal associated with the devil – sprawled on the back of a shield carried by one of the soldiers. The Turkish crescent flutters from one of the city towers in the background. The enemies of Christ have been identified with the

Christ Carrying the Cross, c. 1500 (?)
Oil on panel, 57.2 x 32 cm
Vienna, Kunsthistorisches Museum

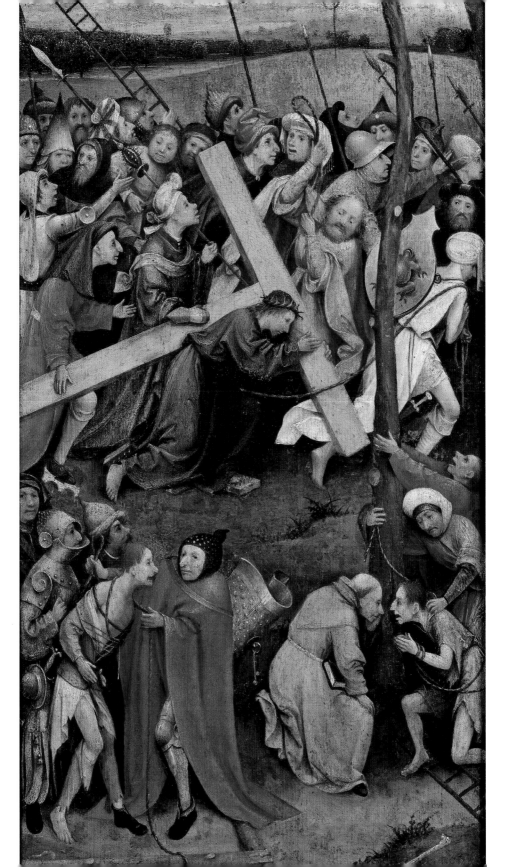

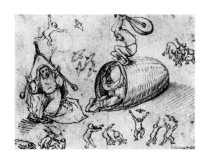

Bosch or his workshop
Woman next to a Man in a Beehive
Pen and bistre, 19.2 x 27 cm
Vienna, Albertina

power of Islam, which in Bosch's day, and long afterwards, controlled the most holy places of Christendom in the Near East.

The Dutch character of these two early works is unmistakable. The Philadelphia *Adoration of the Magi* represents a reworking of a composition that had long been used by Dutch manuscript illuminators. Likewise, the rustic faces and animated gestures of Christ's tormentors in the *Ecce Homo* recall Passion scenes in Dutch manuscripts of the second and third quarters of the fifteenth century.

A related style appears in the Vienna *Christ Carrying the Cross* (p. 19), a statement that holds true even if this panel should indeed be a copy recapitulating the former left-hand wing of a triptych. The head of Christ is silhouetted against a dense mass of grimacing soldiers and ill-wishers, one of them bearing the familiar toad on his shield. Christ's physical agony is heightened by the spike-studded wooden blocks that dangle fore and aft from his waist, lacerating his feet and ankles with every step. This cruel device was frequently represented by Dutch artists well into the sixteenth century. The high horizon is again old-fashioned, as is the lack of spatial recession in the middle distance. In the foreground, soldiers torment the bad thief while the good thief kneels before a priest. The almost frantic intensity of his confession, well-expressed by the open-mouthed profile, contrasts vividly with the passive response of the priest, who seems to suppress a yawn. The very presence of the priest is, of course, an anachronism, probably inspired by scenes that Bosch had witnessed himself at contemporary executions.

This everyday human dimension is also present in *The Conjuror* (p. 21). The original painting, today lost, can be dated with a fair degree of certainty to the early or middle phase of Bosch's career. The technically excellent copy in Saint-Germain-en-Laye may have been executed by a member of the workshop and probably adheres faithfully to the original. A mountebank has set up his table against the gloomy backdrop of a crumbling stone wall. His audience watches spellbound, not – as it is occasionally described in the literature – as the conman conjures a frog from the mouth of an elderly man leaning forward like a puppet, but as he performs the age-old trick of cups and balls. Only one of the crowd, the young man with his hand on the shoulder of his female companion, appears to notice that the old man's purse is being stolen by the conjuror's confederate. The frog probably illustrates the popular figure of speech "to swallow a frog" and symbolizes excessive gullibility. The owl crouched in the basket might signify the diabolical temptation that makes people trapped in the web of illusion. The thief's upturned and hence seemingly innocent gaze and the stupid amazement of the victim are played off in a psychologically sophisticated manner against the amused reactions of the bystanders, while the slyness of the mountebank is conveyed in his sharp-nosed physiognomy. As in the *Christ Carrying the Cross*, Bosch exploits the human face in profile for expressive purposes. The perceptive humour of this picture would be difficult to match in contemporary Flemish painting, but parallels can be found in Dutch manuscript illumination.

It was common in the past to view those of Bosch's paintings that depart from traditional iconography in only a few details as dating from the early part of his career, and to assign those demonstrating the boldest innovations exclusively to his later oeuvre. According to the latest findings, however, this classification is inaccurate. The prominent position of the two thieves in the

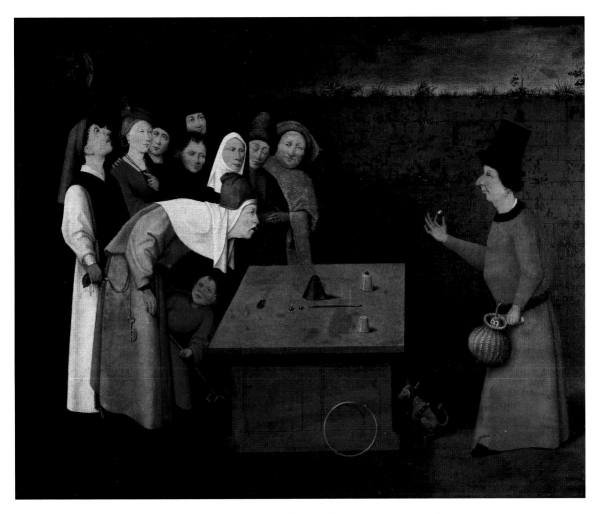

foreground of the Vienna *Christ Carrying the Cross* and the anachronistic motif of a monk hearing confession from one of them are apparently without precedent. Perhaps still more unusual is the tondo on the reverse, depicting a naked child pushing a walking frame (p. 18). This is the Christ Child, whose first halting steps clearly parallel Christ struggling with his Cross on the obverse, while the toy windmill clutched in his hand probably alludes to the Cross itself. Thus Bosch gives us a touching picture of Christ in all his human frailty as he begins the road to his Passion.

Even more unconventional is the *Marriage Feast at Cana* (p. 23), which the earlier literature placed towards the end of Bosch's early period but whose authenticity is now rejected by relatively common consent. Little more than a ruin of its original self (the top corners have been cut off, many heads have been repainted, and a pair of dogs at the lower left may have been added as late as the eighteenth century), the picture may be the work of a certain Gielis Panhedel (alias van den Bossche; c. 1490–after 1545), a Bosch pupil who is also known to have produced work for the Brotherhood of Our Lady in s'Hertogenbosch. The pigments employed in the *Marriage Feast at Cana* include ground blue cobalt glass, which became widespread in

Workshop
The Conjuror, c. 1502 or later
Oil on panel, 53 x 65 cm
Saint-Germain-en-Laye, Musée Municipal

Netherlandish painting only after 1540. Dendrochronological analysis, meanwhile, suggests a substantially later dating. The most recent scholarship now argues in favour of attributing the original composition either to Bosch, as in the past, or to a copyist, whoever he may have been, who supplied a paraphrase. Although the question of who invented the strange iconographical details of the *Marriage Feast at Cana* must therefore remain open, the subject deserves analysis at the very least by reason of the interpretations it has attracted. For it was this panel that Fraenger called as his key witness in support of his thesis that Bosch was a secret member of a free-thinking sect. In the debate that followed, the picture was declared to be a document of Jewish gnosis, and more specifically of heretical Cathar thought, or alternatively an alchemical allegory – to name the most important standpoints. The most "harmless" of these hypotheses claimed that the picture shows an initiation ceremony to mark an admission to the Brotherhood of Our Lady.

The marriage banquet is being held in a richly furnished interior, most probably a tavern, the setting for the Cana story in at least one Dutch Easter play of the period. The miracle of the transformation of water into wine takes place in the lower right-hand corner of the picture. The guests are seated around an L-shaped table dominated at one end by the figure of Christ, who is flanked by two male donors in contemporary dress. Next to the Virgin Mary at the centre of the table appear the bridal couple, who are dressed in "biblical" clothing. This fact has led many interpretors to identify the bridegroom as John the Evangelist. According to medieval legend, at the end of the feast, Christ called to John, saying: "Leave this wife of yours [the same legend held this earthly bride to be none other than Mary Magdalene] and follow me. I shall lead you to a higher wedding." Since John the Evangelist was also considered the "bridegroom" of Ecclesia, the Church, in the exegetical literature, and since the miracle of the wine at Cana was also seen as prefiguring the eucharistic transubstantiation, it follows that the *Marriage Feast at Cana* as a subject may allude to the chief sacrament of the Mass.

In this context, however, what would happen to the evil enchantment that seems to have fallen upon the banquet hall? From the left, two servants carry in a boar's head and a swan, both spitting fire from their mouths. We may frequently read in the Bosch literature that the swan, an ancient emblem of Venus, signifies unchastity. The tendency meanwhile is to qualify it as a luxury dish that was popularly served at lavish feasts of the day. On such occasions, it was prepared so as to provide a fire-spewing "special effect". The same applies to the boar's head. The objects displayed on the sideboard, too, are more sensibly viewed as "showpieces" rather than as "unholy" symbols.

The "child" dressed in white, his back turned to the viewer, who seems to be toasting the bridal couple with a chalice, has attracted a particular wealth of interpretations. In the context of late medieval feasting and celebrations, however, his figure may simply be that of a person of short stature, a dwarf, i.e. individuals who were a regular feature of public banquets. The fact that two such persons of restricted growth are documented as belonging to the Brotherhood of Our Lady in Bosch's day possibly lends further weight, along with many other considerations, to the notion that the painter of this picture has recorded one of the festive gatherings of this Brotherhood. Whatever the case, the *Marriage Feast at Cana* lays mercilessly bare the enormous range of difficulties continually encountered by scholars of Bosch.

Gielis Panhedel (van den Bossche) or later copyist (?)
Marriage Feast at Cana, after 1540 (?) or c. 1560 or later
Oil on panel, 93 x 72 cm
Rotterdam, Museum Boijmans Van Beuningen

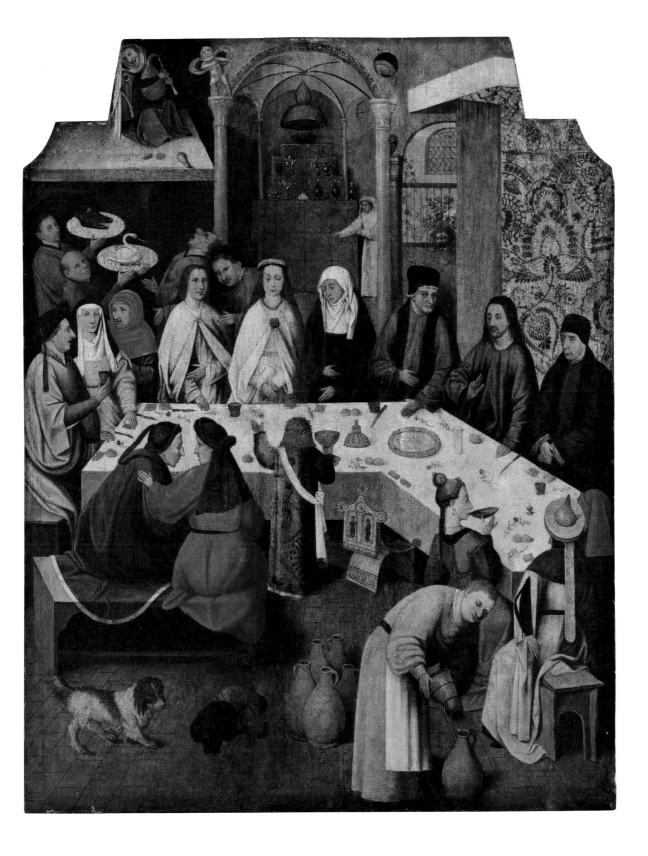

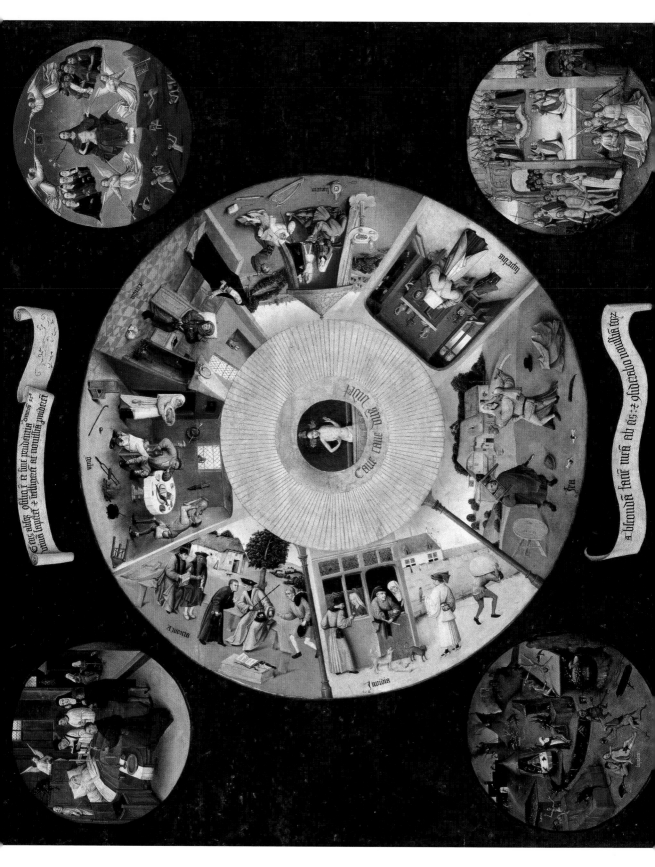

The Mirror of Man

In his *Oration on the Dignity of Man*, composed around 1486, the young Florentine humanist Pico della Mirandola celebrated the excellence and felicity of humankind: man is unique among creatures in possessing a free will, the power to determine his nature and destiny; and through the proper exercise of this will, he can attain the state of angels. Pico thereby lent expression to the optimistic faith of the Italian Renaissance in man's abilities. Some eight years later, Sebastian Brant published the first edition of his *Ship of Fools*, a series of poems satirizing humanity's failings and foibles. "The whole world lives in darksome night," Brant complains, "in blinded sinfulness persisting, while every street sees fools existing." The difference between these two conceptions of man is only a seeming one. Brant's gloomy outlook may be more closely indebted to the Middle Ages, but Pico and Renaissance humanism also continued to acknowledge that man, burdened by the sin of Adam, must struggle against his evil inclinations and must permanently fear sinking to the level of beasts rather than rising with the angels.

The *Tabletop of the Seven Deadly Sins and the Four Last Things*, donated to the Escorial by Philip II in 1574 and today in the Prado (p. 24), offers a detailed exploration of humankind's existential guilt and chances of salvation. The pictures of the Seven Deadly Sins are grouped radially around a circle that symbolizes the Eye of God, in whose pupil Christ emerges from his sarcophagus, displaying his wounds to the viewer. Around the pupil is written: "Cave cave deus videt" (Beware, Beware, God Sees); and just what God sees is mirrored in the outer ring of his eye, where the Seven Deadly Sins are enacted in lively scenes taken from everyday life. The Latin name of each sin is clearly inscribed at the bottom, although in each case, it is conveyed visually quite clearly by the iconography. The men, for example, who are greedily consuming all that the housewife brings to the table, represent the sin of Gluttony. The well-fed gentleman dozing by the fire personifies Sloth; the woman who enters the room from the left, reproachfully holding out a rosary, indicates his neglect of his spiritual duties. Lust is illustrated by several pairs of lovers in a tent; and in Pride, a vain lady admires her new hat, unaware that her mirror is held by an extravagantly bonneted demon. Similar genre scenes illustrate Anger (two men quarrelling before a tavern), Avarice (a judge accepting bribes) and Envy (a rejected suitor gazing jealously at his rival). For the most part, these little dramas are placed against views of the Dutch countryside, or within lovingly detailed interiors.

The short, sturdy and in places rather awkward figures are generally unlike those that we encounter elsewhere in Bosch's art; equally untypical are the hard surfaces, dark outlines and flat, bright colours, dominated by green and ochre. Some scholars have therefore considered the possibility that the

Workshop
Witches
Pen and bistre, 20.3 x 26.4 cm
Paris, Musée du Louvre, Cabinet des Dessins

Bosch or his workshop
Tabletop of the Seven Deadly Sins and the Four Last Things, c. 1485 or more likely 1500–1525
Oil on panel, 120 x 150 cm
Madrid, Museo del Prado

Workshop
The Ship of Fools in Flames
Pen and bistre, 17.6 x 15.3 cm
Vienna, Akademie der bildenden Künste

painted tabletop represents a workshop production. The pendulum has since swung the other way and the work is mostly catalogued among Bosch's early autograph works – in particular following the renewed acknowledgement of the high painterly quality of details such as the Avarice scene and several figures in Envy.

The circular disposition of the Seven Deadly Sins conforms to a traditional scheme. As many writers have assumed, this wheel-like arrangement probably alludes to the extension of sin throughout the world, but the motif was immeasurably enriched when Bosch transformed the circular design into the Eye of God that mirrors what it sees. Here, too, he had ample precedent. The comparison of the Deity to a mirror occurs frequently in medieval literature.

That those who have abandoned God have just reason to dread his glance is affirmed by the banderoles that unfold above and below the central image of the Prado *Tabletop*. The upper one reads: "For they are a nation void of counsel, neither is there any understanding in them. Oh, that they were wise, that they understood this, that they would consider their latter end!" On the lower banderole is written: "I will hide my face from them, I will see what their end shall be" (Deuteronomy 32:29, 20). What their end will be is shown in no uncertain terms in the corners of the panel. Here, in four smaller circles, appear Death, the Last Judgement, Heaven and Hell, the Four Last Things of all men as understood by Bosch and his contemporaries.

Insofar as the Eye of God as it were reflects the Seven Deadly Sins, it functions as a mirror wherein the viewer is confronted by his own soul disfigured by vice. At the same time, however, he beholds the remedy for this disfigurement in the image of Christ occupying the centre of the Eye. It seems likely that the tabletop was used as an object of meditation, particularly that intensive examination of one's conscience that every good Christian had to undertake before going to Confession.

Within its framework of the Seven Deadly Sins, the Prado *Tabletop* embraces all men and conditions of life; in Avarice, however, the reference is more specific, for the vice is represented by a dishonest judge, one of the types of persons deemed particularly susceptible to this sin. In other pictures, Bosch further developed this criticism of specific social classes, sometimes in terms of one or more of the Deadly Sins. He castigates charlatans and quacks and their foolish victims, loose-living monks and nuns, and the rich man more concerned for his property than for his soul, themes that find echoes in many sermons and satirical writings of the period.

A prominent member of this "family" of follies is human gullibility. This is indeed the subject of another picture in the Prado, *The Stone Operation* (p. 27). Formerly considered an early work by Bosch and later assigned to the middle phase of his career around 1490, there are today good grounds for classifying the work as a probably very faithful copy dating from around 1520. In the midst of a luxuriant summer landscape, a surgeon removes an object from the head of a man tied to a chair; a monk and a nun look on. The picture of this open-air operation, its circular shape once more suggesting a mirror, is set within a framework of elaborate calligraphical decoration containing the inscription: "Master, cut the stone out, my name is Lubbert Das."

In Bosch's day, the stone operation was a piece of quackery that claimed to be able to cure the patient of his stupidity through the supposed removal of the stone of folly from his head. Fortunately, it was performed only fictively

Bosch copyist (?)
The Stone Operation, c. 1520 (?)
Oil on panel, 48 x 35 cm
Madrid, Museo del Prado

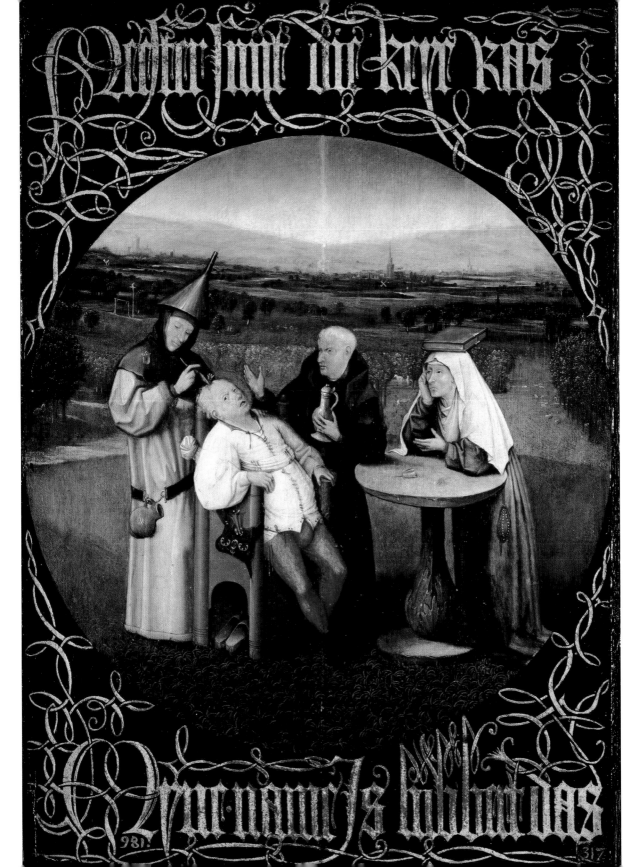

Workshop
The Ship of Fools
Study for the eponymous painting in Paris
Grisaille, 25.7 x 16.9 cm
Paris, Musée du Louvre, Cabinet des Dessins

at annual fairs and other popular gatherings, as it is unlikely that any of those treated would have survived such a procedure. Netherlandish texts, meanwhile, frequently use the name "Lubbert" to designate unusually stupid persons. Netherlandish painters and engravers continued to portray such stone operations until well into the seventeenth century, as did the celebrated Pieter Bruegel the Elder in the late sixteenth century. Nowhere else, however, do we find the funnel on the head of the surgeon – perhaps an allusion to his deceitful intentions – or the book on the head of the nun, perhaps intended as an "encyclopedia" for charlatans, as employed in the Madrid panel. The presence of the monk and the nun (are they in fact monastic figures, or accomplices in disguise?) is also unexplained, but at all events, their apparent acquiescence in the quackery certainly places them in an unfavourable light. It will be noted, too, that what the surgeon extracts from Lubbert's head is not a stone, but a flower; another flower of the same species lies on the table on the right. Their interpretation is the subject of countless and controversial hypotheses in the Bosch literature.

An even harsher condemnation of those in religious orders can be seen in the Paris *Ship of Fools* (p. 29), which a majority of earlier scholars assigned to Bosch's early or middle period. The panel, which has been heavily restored as well as extended at the top, shows a monk and two nuns or Beguines (members of a lay sisterhood who lived in a convent-like community but without binding vows) carousing with a group of peasants in a boat. The oddly constructed boat carries a tree in full leaf for a mast, while a broken branch serves as a rudder. A fool is seated in the rigging on the right.

The possibility cannot be dismissed that the content of the picture makes reference to the best-selling collection of satirical verse by the same title, Sebastian Brant's above-mentioned *Ship of Fools*, which appeared in six editions and numerous translations even during the author's lifetime. But Bosch could also have found his iconographical inspiration elsewhere, as the ship was one of the most beloved metaphors of the Middle Ages. A popular image in literature and the visual arts, for example, was the Ship of the Church manned by prelates and the clergy, which brings its freight of Christian souls safely into the port of Heaven. In Guillaume de Deguileville's *Pilgrimage of the Life of Man*, the Ship of Religion bears a mast symbolizing the Crucifix, and contains castles representing the various monastic orders.

A Dutch translation of this famous work was published in Haarlem in 1486, and it is conceivable that Bosch was familiar with Deguileville's ship and intended his own boat as a parody. Instead of the Cross, the flapping pink banner carries a crescent – not always charged with negative significance in Bosch's work, but in this case probably a reference to the Turkish crescent and hence in line with Christian ideology, with the devil – and we find an owl lurking in the foliage at the top of the mast. Three representatives of the cloistered life have abandoned their spiritual duties to join the other revellers. The monk and one of the nuns are singing lustily, the latter accompanying herself on a lute; they resemble the amorous couples depicted in medieval representations of the Garden of Love: their joint music-making is a prelude to a more physical "interaction". The allusion to the sin of Lust is reinforced by further symbols drawn from the repertoire of traditional Garden of Love scenes: the plate of cherries and the metal wine jug suspended over the side of the boat are props that Bosch had employed for the sin of

The Ship of Fools, c. 1494 or later
Oil on panel, 57.9 x 32.6 cm
Paris, Musée du Louvre

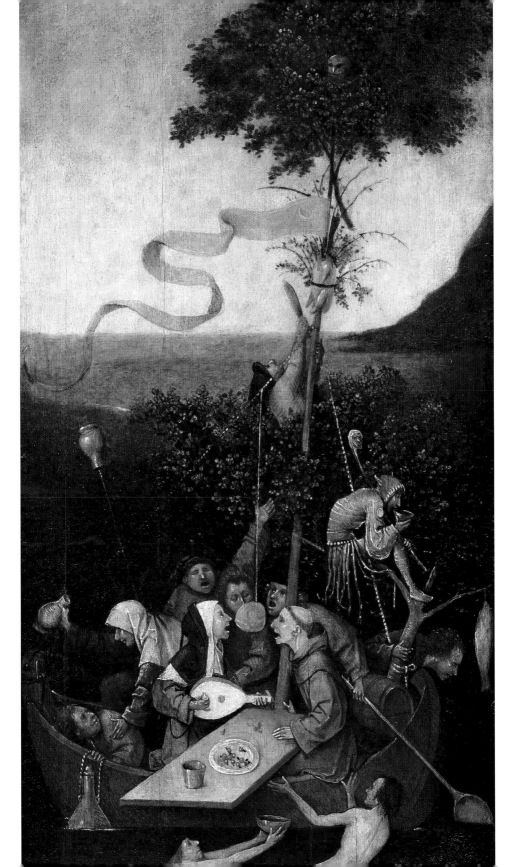

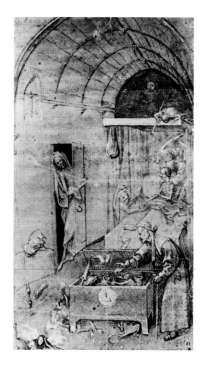

Workshop
Death of the Miser
Study for the eponymous painting in
Washington, DC
25.6 x 14.9 cm
Paris, Musée du Louvre, Cabinet des Dessins

Lust in the Prado *Tabletop*. Gluttony is represented not only by the peasant cutting down the roast goose tied to the mast, but also by the man who vomits over the side of the boat on the right, and by the giant ladle that another member of the merry party wields as an oar. Alongside the boat appear two nude swimmers, one holding out his wine cup for replenishment. The tree-mast may refer, as some authorities believe, to the maypole or May tree of the spring folk festivals, generally a time of moral licence for folk and clergy alike.

The disreputable nature of the boat is explicitly conveyed, finally, by the guzzling fool in the rigging. For centuries the court jester or fool had been permitted to satirize the morals and manners of society through persiflage, and it is in this capacity that he appears in prints and paintings from the mid-fifteenth century on, distinguished by his cap adorned with ass's ears and carrying a baton topped by a small replica of his own vacantly grinning features. He frequently cavorts among revellers and lovers, as in the Lust scene of the Prado *Tabletop*, pointing to the folly of their lewd behaviour.

Lust and Gluttony had long been viewed by the populace as pre-eminent among the monastic vices, and these and other charges were levelled against the various religious orders, and in particular against the mendicant orders, with increasing frequency during the fifteenth century. This period saw the rapid growth of religious houses, some of which supported themselves through weaving and other crafts. That they were more dissolute than before, despite various attempts at monastic reform, would be difficult to determine with any certainty, but it is clear that their considerable wealth and economic competition with the craft guilds brought them into conflict with the secular authorities. We must take account of this background of hostility if we wish to view and understand, in its contemporary context, the frequent condemnation of immorality among monks and nuns pronounced in Bosch's pictures – a condemnation that would be granted particularly vehement expression in the later *Haywain*.

The intimate association between Gluttony and Lust in the medieval moral system was furthermore expressed by Bosch in a fragment of a painting at Yale University. This fragment originally formed the lower part of the *Ship of Fools* but was later sawn off. Rather than establishing a specific link between these two sins and monastic life, however, it offers a more general *Allegory of Gluttony and Lust* (p. 31). Gluttony is personified by the swimmers in the upper left-hand corner who have gathered around a large wine barrel straddled by a pot-bellied peasant. Another man swims closer to shore, his vision obscured by the meat pie balanced on his head. This scene is followed, on the right, by a pair of lovers in a tent, another motif reminiscent of the Lust scene in the Prado *Tabletop*. That they should be engaged in drinking wine is entirely appropriate: the aphorism "Sine Cerere et Libero friget Venus" (Without Ceres and Bacchus, Venus freezes), from the Ancient Roman playwright Terence, was well known to the Middle Ages, whose moralizers never tired of driving home to their audiences the lesson that Gluttony and Drunkenness lead to Lust.

The subject addressed in the panel *Death of the Miser* (left) is by no means as clear as the title – a later formulation – would suggest. The raw-boned elderly man who is placing gold coins into the devil's chest, while holding a rosary with a certain lack of concern in his other hand, embodies

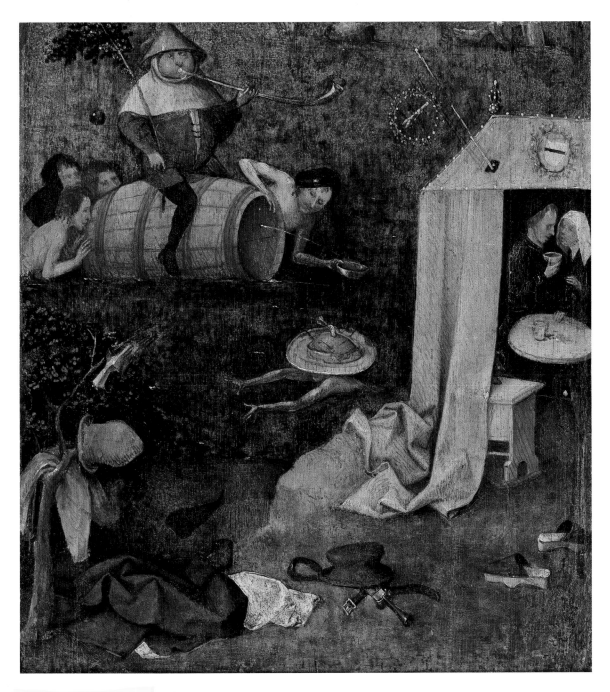

Allegory of Gluttony and Lust, c. 1494 or later
Oil on panel, 35.8 x 32 cm (sawn-off lower
section of the *Ship of Fools*, p. 28)
New Haven, Yale University Art Gallery, The
Rabinowitz Collection, Gift of Hanna D. and
Louis M. Rabinowitz

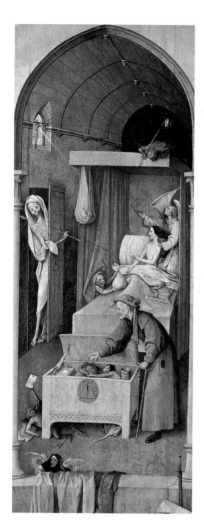

the miserly type *par excellence*. But is the much younger-looking man who lies dying in the background, in a high, narrow bedchamber whose compositional arrangement recalls many fifteenth-century miniatures, really identical with the figure in the middle ground? Is he truly the miser's simultaneous *doppelgänger*? Or is he a different person, one who is still agonizing over the choice between the crucifix and the bag of gold, between Heaven (the angel) and Hell (the devil), in view of the skeleton armed with an arrow? And what is the significance of the still life in the foreground? Does it identify the dying man as a nobleman? The inspiration behind this scene was probably a popular fifteenth-century devotional work, the *Ars Moriendi* or "Art of Dying", which was printed many times in Germany and the Netherlands. This little manual describes how the dying man is exposed to a series of temptations by the demons clustered around his bed and how, each time, an angel consoles him and strengthens him in his final agony. In the book, the angel is ultimately successful and the soul is carried victoriously to Heaven as the devils howl in despair below.

It is probable that this tall rectangular panel and the *Ship of Fools* discussed above formed part (together with a lost central panel) of a triptych that portrayed the Seven Deadly Sins.

Death of the Miser, c. 1494 or later
Oil on panel, 92.6 x 30.8 cm
Washington, DC, National Gallery of Art

The Last Judgement

While sin and folly occupy a prominent place in Bosch's art, their significance can be fully appreciated only within the context of a larger medieval theme, the Last Judgement. The Day of Judgement marks the final act of the long history of humankind that began with the Fall of Adam and Eve and their expulsion from Eden. It is the day when the dead shall rise from their graves and Christ shall come a second time to judge all men, rewarding each according to his merits. As Christ himself foretold, the elect will enjoy the eternal bliss prepared for them "from the foundation of the world", while the damned will be condemned to the "everlasting fire prepared for the devil and his angels" (Matthew 25:34, 41). Time will cease and eternity shall begin.

The preparation for this Final Day was one of the chief concerns of the medieval Church. It taught the faithful what conduct would enable them to be numbered among the blessed; it warned backsliders and evildoers of the awful punishment that awaited them if they failed to reform. The unending torments of the damned were described, in lurid details, in countless books and sermons, while various spiritual meditations focused upon the Last Judgement and Hell.

Even if the Bosch literature of the twentieth century is overly simplistic in assuming that everyone in the late Middle Ages feared the imminent end of the world, it is nevertheless true that a number of voices predicting just such an approaching catastrophe made themselves heard. One such was Sebastian Brant, for example, whose name we have already encountered. Brant was convinced that the sins of humankind had multiplied to such an extent that the Last Judgement must surely be close at hand. Other writers represented the world on the threshold of the final age, in which the prophecies described in the Revelation of St John would soon come to pass. Plagues, floods and other natural disasters were regarded as manifestations of the wrath of God and current political events were searched anxiously for signs of the Last Emperor and of the Antichrist.

Rarely is the apocalyptic fear overshadowing this threshold between the Middle Ages and the Renaissance given more vivid expression than in the *Last Judgement* triptych today housed in Vienna (pp. 37 and 39). The triptych is considered by most scholars, even if not by all, to be a genuine work by Bosch (an attribution supported in particular by the painterly quality of the underdrawings and of those areas not spoilt by later interventions). The *Last Judgement* is prefaced on the outer wings by the figures of St James the Greater and St Bavo, painted in grisaille (pp. 34 and 35). Despite the gloomy and threatening landscape through which St James moves, neither this panel nor its companion prepares us for the Apocalyptic

Bosch or his circle
Studies of Monsters
Pen, 8.6 x 18.2 cm (each)
Berlin, Kupferstichkabinett SMPK

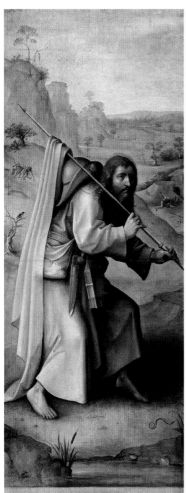

St James the Greater
Left outer wing of the *Last Judgement*
Grisaille on panel, 167 x 60 cm
Vienna, Akademie der bildenden Künste

scenes that unfold inside the altarpiece. Here, adhering relatively strictly to the canonical texts, the First and Last Things are depicted across the three inner panels, beginning with the Fall of Man on the left wing.

The story recounted in the second and third chapters of Genesis has been placed in a lush garden; in the foreground, we see the creation of Eve, followed by the temptation of the First Couple. In the middle distance, Adam and Eve are expelled from Eden by an angel. Their Fall is paralleled above by the expulsion from Heaven of the Rebel Angels, who are transformed into monsters as they descend to earth. Although the revolt of proud Lucifer and his followers is not mentioned in Genesis, it appears in Jewish legends and entered Christian doctrine at an early stage: Lucifer, prince of the sinful angels, tempted Adam to commit a similar act of sinful temerity. The Devil thereby acted out of jealousy, knowing that Adam and Eve's offspring would one day fill the places left vacant by the fallen angels. In this left-hand panel of the triptych, Bosch thus depicts the entrance of sin into the world and accounts for the necessity of the Last Judgement.

Most contemporary representations of the eschatological drama, including, for example, Rogier van der Weyden's *Last Judgement* polyptych painted between 1443 and 1451 and today housed in the Hôtel Dieu in Beaune, focus chiefly upon the judgement scene taking place in Heaven and describe the felicity of the saved as fully as the pains of the lost. Bosch deviates from this model insofar as he portrays the divine court in a small and marginal manner at the top of the central panel and keeps the number of the elect extremely small. The majority of humankind, however, is engulfed in the universal cataclysm that rages throughout the deep, murky landscape below.

This vast panoramic nightmare represents the earth in her final death throes, destroyed not by water as Dürer and Leonardo were to envision it, but by the fire foretold in a thirteenth-century hymn, the sombre *Dies Irae*: "Day of Wrath, that day when the world dissolves in glowing ashes." It may also be assumed that Bosch's vision was shaped by the account of the last days given in the Revelation of St John, a book that enjoyed renewed popularity in the late fifteenth century: Albrecht Dürer's famous woodcut illustrations of the Apocalypse appeared in print in 1498. The wide valley dominating the central panel of Bosch's triptych may represent the Valley of Jehoshaphat, which, on the basis of several Old Testament references (Joel 4:2, 12), was traditionally thought to be the site of the Last Judgement, with the walls of the earthly Jerusalem blazing in the background. In any event, earth has become indistinguishable from Hell, depicted on the right wing, out of which the army of Satan swarms to attack the damned: the eternity of torment has begun.

The mystics claimed that the most grievous pain suffered by the damned in Hell was the knowledge that they were forever deprived of the sight of God. For most people, however, the torments of Hell chiefly affected the body and were so terrible that, as one medieval sermon expresses it, the pains of this life will seem but a soothing ointment in comparison. For Bosch, too, the agony of Hell is mainly physical: the pale, naked bodies of the damned are mutilated, gnawed by serpents, consumed in fiery furnaces and imprisoned in diabolic engines of torture. The variety of torments seems infinite. In the central panel, one man is slowly roasted on a spit,

basted by an ugly little creature with a bloated belly; nearby, a female demon has sliced up her victim into a frying pan, like a piece of ham, to accompany the eggs at her feet. An infernal concert appears in the right wing, conducted by a black-faced monster.

The Hell scene in the Prado *Tabletop* shows each of the Deadly Sins accompanied by its suitable punishment. Whether or not Bosch consistently followed this formula in the *Last Judgement* would be difficult to determine, but it is nevertheless possible to establish a compelling link between some of the punishments depicted and specific sins. Thus the avaricious are boiled in the great cauldron just visible beneath one of the buildings in the central panel. Around the corner, a fat glutton is forced to drink from a barrel held by two devils; the source of his dubious refreshment can be seen squatting in the window overhead. The lascivious woman on the roof above suffers the attentions of a lizard-like monster slithering across her loins, while being serenaded by two musical demons. On the cliffs to the right, across the river, blacksmith-devils hammer other victims on anvils, and one is being shod like a horse; these unfortunate souls are guilty of the sin of anger.

Some of these punishments can be associated with specific sins on the basis of the correponding inscriptions on the Prado *Tabletop*. Others occur in the visionary "guidebooks" to Hell that flourished during the Middle Ages, and that described the infernal punishments meted out to sinners as seen through the eyes of persons who had returned from the underworld. The best known of these "eyewitness" accounts is, of course, Dante's *Inferno* from the first third of the fourteenth century, which influenced generations of Italian artists. Although Bosch followed none of these texts slavishly, he must have been acquainted with many of them. (Whether he was familiar with Dante's verse epic or even just excerpts from it, however, we do not know.) The influence of such accounts can be seen not only in the manner of punishments he portrays, but also in the general topography of his Hell, including such features as the burning pits and furnaces, and the lakes and rivers in which the damned are immersed. Some of his monsters are also derived from traditional literary and visual sources. The vaguely anthropomorphic devils, such as those in the blacksmith scene of the central panel, occur in many earlier Last Judgement scenes. The toads, adders and dragons that crawl over the rocks or gnaw at the vital parts of their victims were likewise long-established members of the infernal inventory when Bosch integrated them within this and other of his compositions.

Into this more or less common fauna of Hell, which inhabited not least the borders of manuscript illumination, Bosch nevertheless introduced new and more frightening species whose complex forms and composite bodies defy precise description. Many display bizarre fusions of animal and human elements, sometimes combined with inanimate objects in a seemingly organic fashion. To this group belongs the bird-like monster who helps carry a giant knife in the centre panel; his torso develops into a fish tail and two humanoid legs, shod in a pair of jars. To the right, an upturned basket darts forward on legs, a sword clutched in its mailed fist. Disembodied heads scuttle about on stubby limbs; others possess bodies and limbs that glow in the darkness. Several fiends blow musical instruments

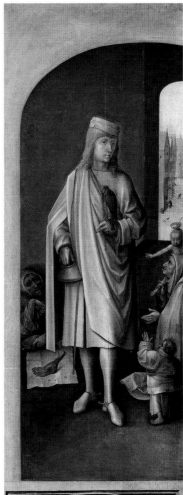

St Bavo
Right outer wing of the *Last Judgement*
Grisaille on panel, 167 x 60 cm
Vienna, Akademie der bildenden Künste

thrust into their hindquarters, bringing to mind the farting devil that Dante encountered on his journey through Hell (*Inferno*, XXI, 139).

In the way that these forms seem to transform into hybrids before our very eyes, Bosch effectively expresses the medieval conception of Hell as a state where the divinely ordained laws of nature have disintegrated into repugnant chaos.

In the final analysis, however, it is difficult for us to experience Bosch's Hell as did his contemporaries. Thoroughly acquainted, from literature and from innumerable sermons, with the atmosphere of Hell and the inhuman conditions suffered by the damned, they might have experienced by association the alternation of extreme heat and cold, and choked "synergetically" on the smoke and the fetid stench arising on every hand. They would probably have heard the screeching and hissing of the devils and, above all, the cries of the tormented. Not only did the agony of the damned persist at its highest intensity for all eternity, but even the most horribly mutilated souls were perpetually "recreated" in order to be able to endure their sufferings with renewed strength.

The Vienna triptych shows the Last Judgement that embraces all men, the biblical grand finale that marks the end of human history. In other literary sources of Bosch's day, however, the torments of the damned are described not as if happening at some unspecified time in the future – as he portrays them in the Vienna altarpiece – but as taking placing in the present, in Purgatory. One such source was the *Vision of Tundale* (also known as the *Visio Tnugdali* or *Visio Tondali*), the most widely publicized of all medieval journeys through the underworld, which was originally recorded at the start of 1149 by a monk named Marcus in the Regensburg Schottenkloster monastery and was published in Dutch translation by Gerardus Leempt in s'Hertogenbosch in 1484. These writings – which evidently provided a source of inspiration for Bosch – reflected a belief in a particular judgement, a private reckoning to which each person had to submit immediately upon his death; according to his merits, he was then dispatched to a place of torment or bliss, there to await the Last Judgement. Evolved in the High Middle Ages and increasingly accepted over the following centuries, this doctrine was treated by Denis the Carthusian in his *Dialogue on the Particular Judgement of God*, for example. As Albert Châtelet* has shown, it also inspired Diric Bouts in his representations of earthly Paradise and the fall of the damned. The two wings of a former *Last Judgement* triptych (c. 1470; Paris, Louvre) by Bouts may have been in Bosch's mind when he painted the *Four Afterlife Panels* today housed in the Doge's Palace in Venice (pp. 40–41).

The *Afterlife* panels have been disfigured by heavy overpainting and darkened varnish. Even though no general consensus has yet been reached amongst specialists as to their authorship, the attribution of these fantastical, visionary scenes to Bosch himself is nonetheless plausible. In one of the two panels (whether formerly the left or right wing of a triptych remains disputed) that together "stage" the scene of Paradise, we see the elect shepherded by angels into a rolling landscape, in which the Spring of Life issues from a decorative fountain in the background. This is perhaps "only" the Terrestrial Paradise, a sort of intermediate stage where the saved were cleansed of the last stain of sin before being admitted into the ultimate

* A. Châtelet: "Sur un Jugement Dernier de Dieric Bouts", in: *Nederlands Kunsthistorisch Jaarboek*, XVI (1965), 17–42.

Paradise
Left wing of the *Last Judgement* triptych
Oil on panel, 167.7 x 60 cm
Vienna, Akademie der bildenden Künste

Hell
Right wing of the *Last Judgement* triptych
Oil on panel, 167 x 60 cm
Vienna, Akademie der bildenden Künste

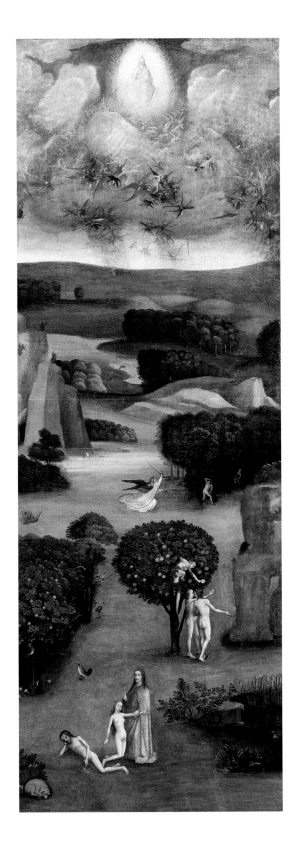
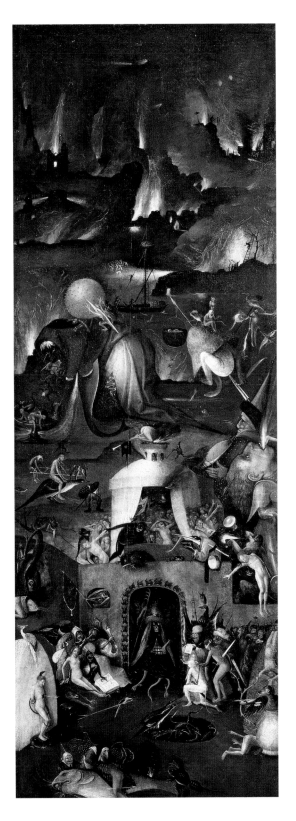

presence of God. Already one group of souls looks expectantly upwards. Several such gardens are described in the *Vision of Tundale*, and the Terrestrial Paradise is shown in many mystery plays of the period. It was frequently identified with the Garden of Eden, thought still to exist on earth on some remote mountain inaccessible to man – a belief that probably influenced the steep terrain to be seen in the Terrestrial Paradise as pictured by Bouts and Bosch.

In his *Terrestrial Paradise* Bosch has followed Bouts's composition fairly closely, departing from it in only one significant respect. Whereas Bouts showed the entry of the saved into Heaven taking place above the earthly Paradise, Bosch reserved this scene for a separate panel, the *Ascent of the Blessed*, which – when measured against all other examples of the day – presents an incomparably mystical vision of celestial translation. Shedding the last vestige of their corporeality, the blessed souls float upwards through the night, with only the gentlest hint of support from their angelic guides. They gaze with ecstatic yearning towards the great light that bursts through the darkness overhead. This funnel-shaped radiance, with its distinct segments, probably owes much to contemporary zodiacal diagrams, but in Bosch's hands it has become a shining corridor through which the blessed approach that final and perpetual union of the soul with God that is experienced on earth only in rare moments of spiritual exaltation. "Here the heart opens itself in joy and in desire," so the Flemish mystic Jan van Ruysbroeck tells us, "and all the veins gape, and all the powers of the soul are in readiness."

The ascent of the blessed into the *coelum empyreum*, the uppermost flaming sphere of Heaven, is counterbalanced in one of the pendants by the descent of the damned into the pit of Hell. Here, too, Bosch essentially followed the version by Bouts but once again transformed the more prosaic aspects of the earlier composition. The damned hurtle past in the darkness, seized upon by devils and scorched by Hellfire spitting through fissures in the rocks. In the second of these underworld panels, the viewer is offered a truly terrible view into Hell: a craggy mountain belches forth flames against a fiery sky, while the souls struggle helplessly in the water below. Not all the torments are physical in nature: oblivious to the bat-winged devil tugging at him, one soul sits on the shore in a pensive attitude, seemingly overwhelmed by remorse. Hell, no less than Heaven, has been interpreted in the spiritual sense of the mystics.

Bosch portrayed the fauna of Hell in inexhaustible variety throughout his oeuvre. In a group of drawings originating from his workshop, monsters proliferate in a multitude of shapes, no two exactly alike (pp. 50–51). Legs sprout from grotesquely grinning heads, obscene bladder-like forms develop snouts and legs; some creatures are all head or rump. This taste for monsters Bosch shared with his age, which was fascinated by the grotesque and the unnatural. Such prodigies were often interpreted as portents of impending disaster and as heralds of catastrophe. Although the two Venice *Hell* panels remain unique in Bosch's work, the – to be sure, unverifiable – information that they were in the possession of Cardinal Grimaldi in Venice in 1521 may be taken to indicate that infernal landscapes of this type were highly popular amongst Italian collectors of the High Renaissance, in other words amongst contemporaries of Raphael and Michelangelo and

Last Judgement, c. 1482 or after 1504
Central panel of the triptych
Oil on panel, 163.7 x 127 cm
Vienna, Akademie der bildenden Künste

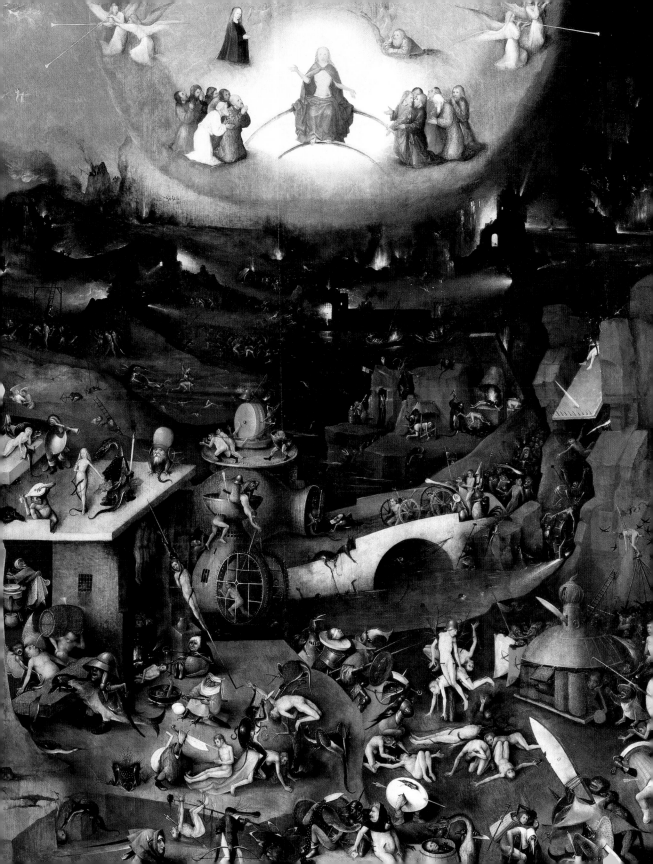

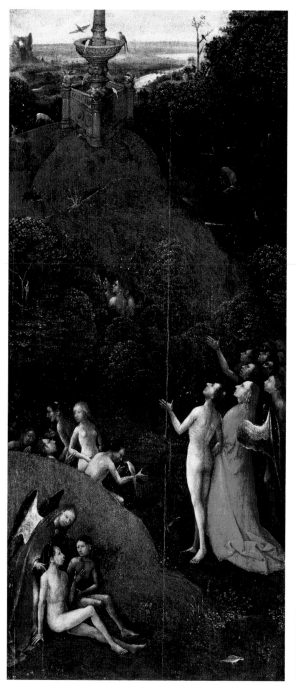

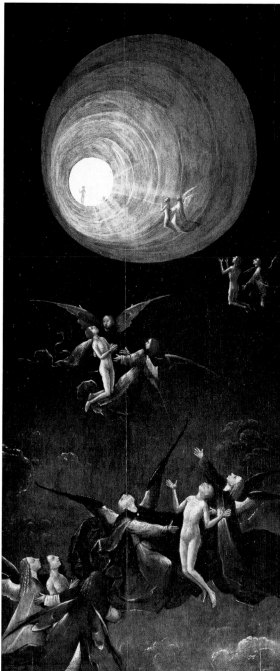

Four Afterlife Panels, c. 1490 or later
Oil on panel, 87 x 40 cm (each)
Venice, Palazzo Ducale

Terrestrial Paradise and *Ascent of the Blessed*

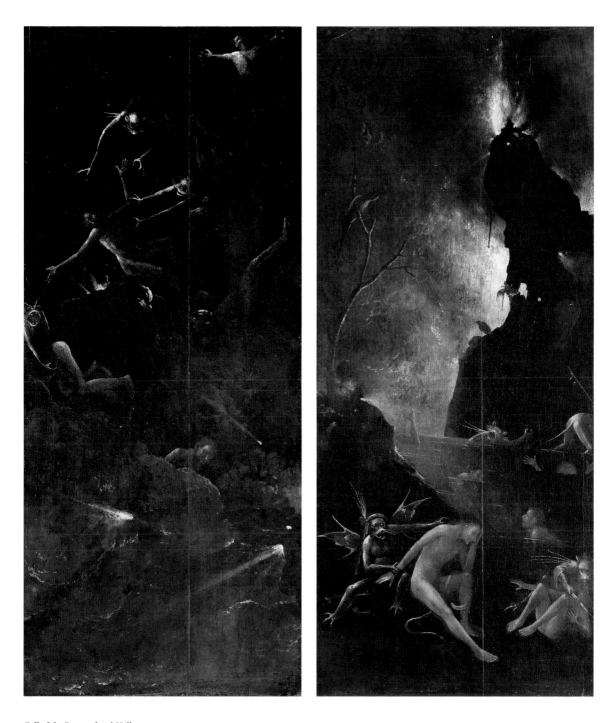

Fall of the Damned and *Hell*

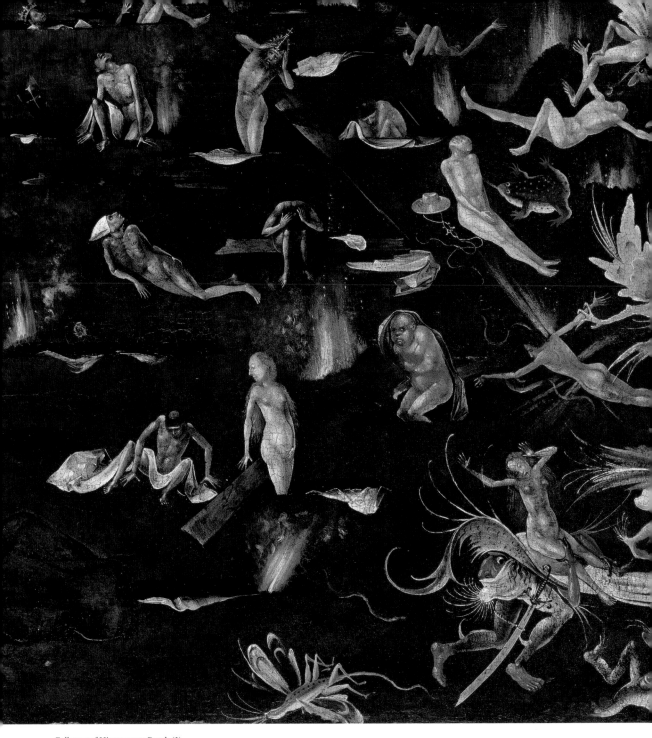

Follower of Hieronymus Bosch (?)
Last Judgement (fragment), c. 1515/20 (?)
Oil on panel, 60 x 114 cm
Munich, Alte Pinakothek

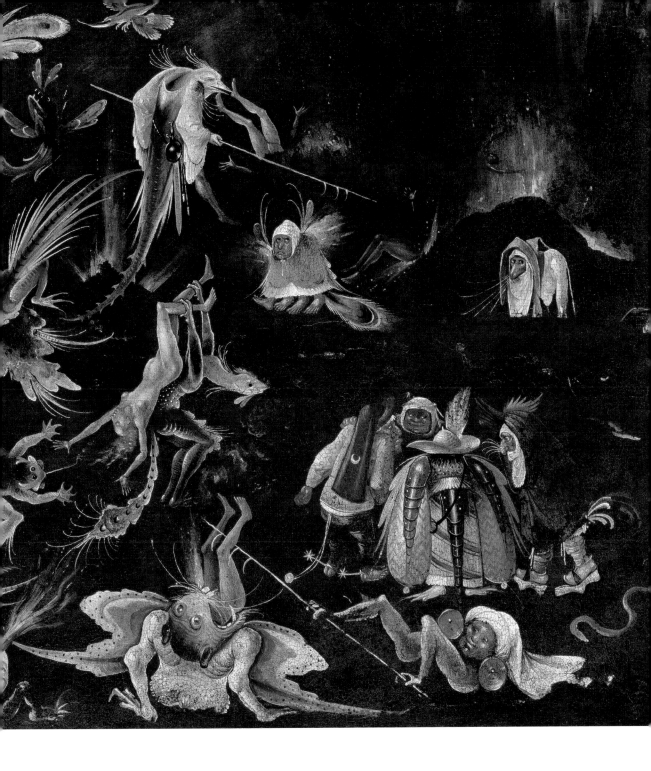

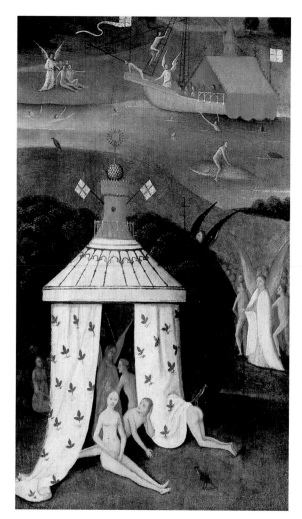

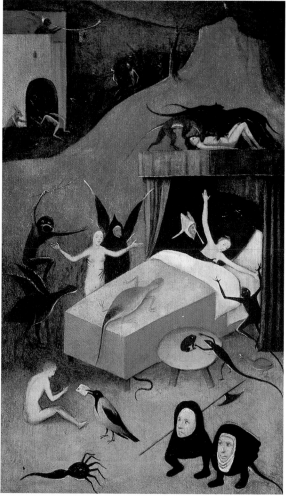

Wing fragments of a *Last Judgement*

Paradise
Oil on panel, 33.9 x 20 cm
New York, Private Collection

Death of the Reprobate
Oil on panel, 34.6 x 21.2 cm
New York, Private Collection

amongst connoisseurs who evidently savoured the "exotic" and sensational flavour of these *grilli* by Bosch and his circle.

The Alte Pinakothek in Munich houses the sadly damaged fragment of a *Last Judgement* (p. 42-43). Some authors have sought to identify this fragment as part of the altarpiece commissioned by Philip the Handsome in 1504, but it was probably done somewhat later, namely towards the end of Bosch's life, if it is autograph; it seems more plausible, however, to attribute it to a copyist in the years around 1515/20. A piece of drapery visible in the lower left-hand corner is all that remains of a figure that must have been much larger in scale than the other figures in the fragment. Perhaps it represented an oversized St Michael in the act of weighing souls, such as appears in Rogier van der Weyden's triptych at Beaune. Behind and to the right of the drapery, the resurrected slowly climb out of their graves, among others, a king and several ecclesiastics, all distinguished by their headdresses. Around them dart monsters whose gossamer wings and long waving filaments and antennae glow phosphorescently against the dark ground.

The Triumph of Sin

For Bosch, sin and folly were the fundamental conditions of human existence and Hellfire the destiny facing most of humankind. He lent pointed expression to this deeply pessimistic view of human nature in the triptychs of the *Haywain* and the *Garden of Earthly Delights*.

The *Haywain* triptych exists in two versions, one in the Real Monasterio El Escorial (pp. 48–49 and 62), the other in the Prado, Madrid (p. 46). Both are in poor condition and have been heavily restored, and in both cases the outer wings fall significantly short of the central panel in terms of artistic quality. The authorities disagree as to which of the two versions is the original, or indeed whether both are copies that recapitulate – with more or less proficiency – a lost original (at least as far as the central panel is concerned). The striking pictorial invention is unquestioningly attributed to Bosch, however. Surprisingly, scholarly opinions are less divided over this altarpiece than, for example, over the *Garden of Earthly Delights*, and are oriented relatively closely towards the information provided by the Escorial librarian Fray José de Sigüenza in 1605. As in the Vienna *Last Judgement*, the left inner wing presents the Creation and Fall of Man (reversing, however, the sequence of episodes, which now runs from background to foreground) and the expulsion of the Rebel Angels, while the right inner wing is occupied by a view of Hell. The central panel, however, presents a most singular image: a great haywain lumbering across a vast landscape and followed by the great of this world on horseback, including an emperor and a pope thought by some to be Alexander VI, the Borgia pope infamous for his amorality. The lower classes – peasants and burghers as well as nuns and clergy – snatch tufts of hay from the wagon or fight among themselves for the handful they have already managed to grab. In a variation of a motif already encountered in the Prado *Tabletop of the Seven Deadly Sins* (p. 24), this frantic activity is witnessed by Christ. Appearing high overhead and surrounded by a golden glory, however, he seems not just distant but almost distanced from the scene below. Except for an angel kneeling and praying on top of the haystack, no one notices the Divine Presence; and, above all, no one notices that the wagon is being pulled by devils towards Hell and damnation.

Bosch's paradoxical conveyance is not simply an expeditious means of getting to Hell; it illustrates, in fact, one specific aspect of human frailty, of which hay was a traditional symbol. A Netherlandish song of about 1470 tells us that God has heaped up good things on the earth like a stack of hay for the benefit of all men, but that each man wants to keep it all to himself. Being a commodity of low value, moreover, hay also symbolizes the worthlessness of all worldly gain. This is certainly the meaning of the allegorical haycarts that appeared in several Flemish engravings after 1550. A haycart

Bosch or his circle
Scenes in Hell
Pen and bistre, 16.3 x 17.6 cm
Berlin, Kupferstichkabinett SMPK

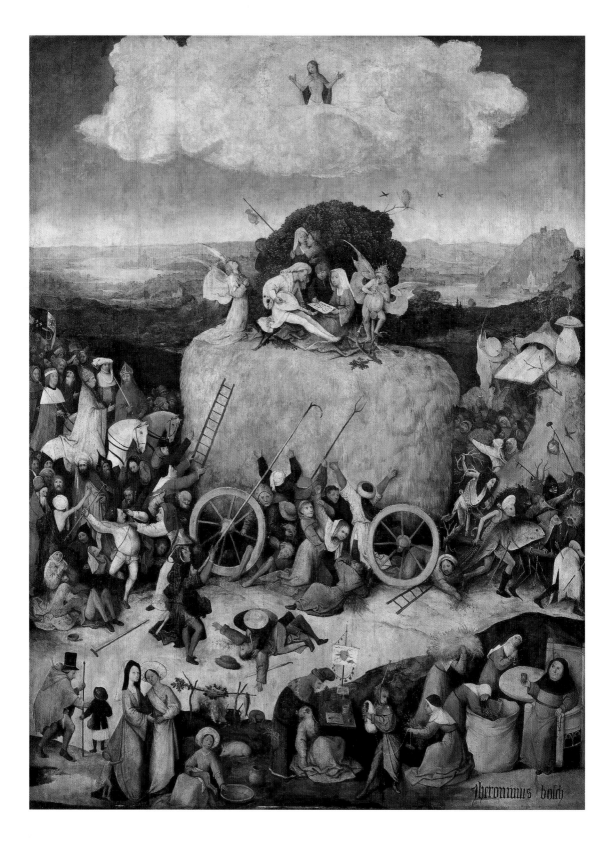

also formed part of a religious procession at Antwerp in 1563; according to a contemporary description, it was ridden by a devil named Deceitful, and followed by all sorts of men plucking the hay, so as to show that worldly riches are "al hoy" (all hay).

The above-mentioned allegorical haycart engravings appeared some years after Bosch's death and were most probably inspired by his *Haywain* triptych, which we may confidently assume held the same message. The fact that the Antwerp haycart of 1563 was a carnival wagon has led some scholars to suggest that Bosch, in turn, was influenced by similar floats. The *Haywain* thus analyses a humankind given over to sin, completely unmindful of God's law and oblivious to its own pending fate. Amongst all the conceivable vices, however, Bosch here focuses on one in particular, namely the desire for worldly gain, or Avarice, whose sub-categories are elaborated in the adjacent figure groups very much as they are in the old handbooks on the Virtues and Vices. According to the profound warning in the *King's Dream*, written by Laurent Gallus in 1279, Avarice leads inevitably to discord, violence and ultimately even murder, all of which are depicted in narrative sequences in the open space before Bosch's cart. If the princes and prelates complacently jog along behind, holding themselves aloof from this struggle, it is simply because the whole of the haystack is, so to speak, already in their possession; in their conceited complacency, however, they make themselves guilty of the sin of Pride. Avarice, as we know, also leads people to cheat and deceive; the man wearing a tall hat and accompanied by a child in the lower left-hand corner is most likely a false beggar (of the kind patronized by the elderly female character of Avarice in Deguileville's *Pilgrimage of the Life of Man*). The quack physician in the centre has set up his table with charts and jars designed to impress his victim; the purse at his side stuffed with hay alludes to his ill-gotten gains. Several nuns in the lower right-hand corner push hay into a large bag, supervised by a seated monk whose gluttonous tendencies are revealed by his ample waist.

The meaning of some of the other groups remains unclear, as does the deeper significance of the lovers on top of the haystack. That they illustrate the sin of Lust we can conclude from the appearance of similar figures in the Prado *Tabletop*, but are they also implying that the pursuit of the pleasures of the flesh, which often involves financial expenditure, can counteract Avarice? Although a class distinction may be observed between the rustic couple kissing in the bushes behind and the somewhat better-dressed pair singing and playing in front, the music being made by this more sophisticated couple undoubtedly also serves as the musical accompaniment to Lust; for the devil standing nearby, piping some lascivious tune through his trumpet nose, has already lured their attention away from the angel praying on the left.

Such details serve to reinforce Bosch's primary theme of the global triumph of Avarice. Through the general tenor of the *Haywain*, nevertheless, the strains of other voices sounding a metaphorical note continually make themselves heard. In the sixteenth century, hay also possessed connotations of falsehood and deceit, and to "drive the haywain" with someone was to mock or cheat him. When we read that the demon who rode on top of the haywain of 1563 was called Deceitful, and when we note that the body of the musical devil on top of Bosch's haywain is pale blue (a "broken" tone, which in those days was the traditional colour of deceit), the full implications of

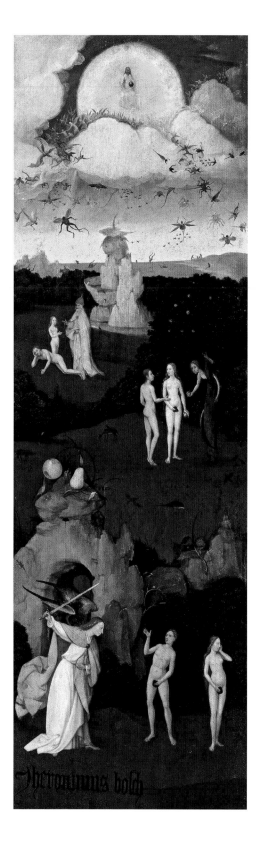

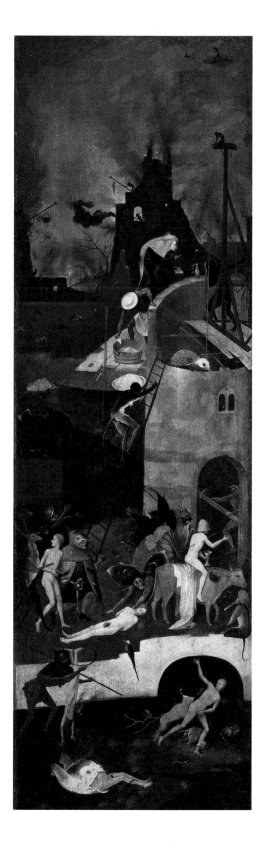

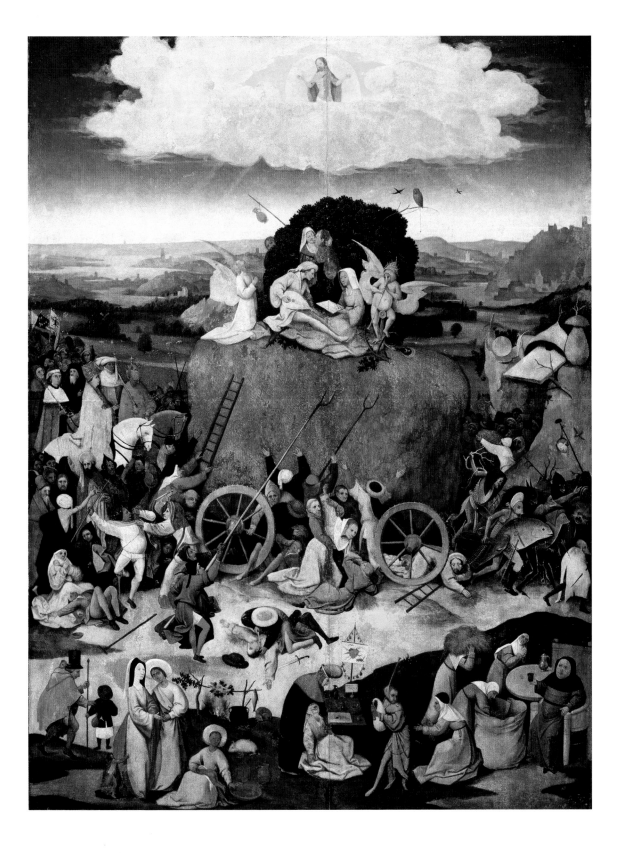

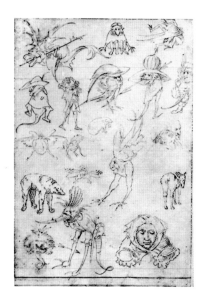

Workshop
Studies of Monsters
Pen and bistre, 31.8 x 21 cm
Oxford, Ashmolean Museum

Bosch's load of hay become even more clear: not only have worldly goods and honours no intrinsic value, they are also employed by Satan and his army as bait to lure men to ultimate, infernal destruction.

In composition, the Hellscape of the right wing of the *Haywain* stands between the discursive panorama of the Vienna *Last Judgement* (p. 39) and the monumental simplicity of the *Hell* panel in Venice (p. 41). Reminiscent of the latter work, too, are the tall ruin captured in bizarre silhouette against the flaming background and the damned souls struggling helplessly in the waters of Hell below. The foreground is dominated by a new motif, however, a circular tower whose process of construction is shown in circumstantial detail. One demon climbs a ladder with fresh mortar for the devil masons on the scaffolding above, while a black-skinned companion raises a floor beam with a hoist. The significance of this feverish activity is not clear. Towers abound in medieval descriptions of Hell, but the devils are usually too busy ministering to their victims to engage in such architectural enterprises. There nevertheless existed a description, by Pope St Gregory the Great, of a vision of Heaven in which houses were constructed of golden bricks, each brick representing an "almsdeed" or charitable act by someone on earth. These houses were intended to receive the souls of the good. Perhaps Bosch has represented the hellish counterpart of this heavenly building programme, in which avarice, and not almsdeed, supplies the stones. In his account of the *Haywain* triptych in 1605, Sigüenza expresses a similar thought when he describes the tower as being built to accommodate all those entering Hell; the stones are the "souls of the wretched damned". On the other hand, Bosch's tower may be a parody of the infamous Tower of Babel with which men sought to storm the gates of Heaven itself. In this case, it would symbolize the sin of Pride, the hubris that caused the fall of the Rebel Angels and that is also exemplified by the worldly prince and prelate and their retinue riding behind the haywain in the middle ground.

Other punishments can also be related to the sins encountered in the central panel. On the bridge leading to the infernal tower, a squad of devils torments a poor naked soul astride a cow. This hapless figure was probably inspired by the vision of Tundale, who, during his fictive tour of Hell, was forced to lead a cow across a narrow bridge as punishment for stealing one of his neighbour's cattle. On the bridge, he encountered those who had robbed churches and committed other acts of sacrilege, a detail that may have suggested the eucharistic chalice clutched by Bosch's figure. The man on the ground with a toad gnawing his genitals suffers the fate of lechers, while greed is appropriately punished by a fish-like monster in the foreground. Above him, a hunter-devil sounds his horn on the left, his human quarry gutted like a rabbit and dangling upside down from a pole. Several dogs rush ahead of their master to bring down a couple beneath the bridge.

Complex though its ramifications may be, the basic meaning of the *Haywain* is relatively simple. Even if we know nothing about the metaphorical use of hay in the sixteenth century, we can easily grasp the fact that Bosch is commenting on an unpleasant aspect of human nature. The situation is not so straightforward in the case of Bosch's most famous triptych, one that has been called by various titles, of which the *Garden of Earthly Delights* remains the most enduring (pp. 54 and 55).

Such was the fascination exerted by the central panel upon viewers even in Bosch's own day that it became the only part of the triptych to be separately copied. The scene filled with high-keyed colours is not the Paradise that appears on the left wing, but nor is it an idyllic inner world. Taking up the pictorial type of the late medieval "universal landscape", an evenly lit park landscape seems to extend across the globe. It is populated by happily unselfconscious naked figures, members of all different races, who feel utterly at home in nature since they are evidently an integral part of the natural world themselves. The teeming activities filling the pictorial space only clear in the middle ground, where men riding horses, unicorns and every possible kind of mount revolve in a wide circle around a pool of seductive maidens. In the centre behind, an enormous capsule, coloured blue like a terrestrial globe, rises out of a lake. Four other phantasmagorical "architectural" structures, composed of partly vegetable, partly petrified and crystalline forms, are situated around the lake shore.

Throughout this entire bewildering puzzle, nude men and women nibble at giant fruits, consort with birds and animals, frolic in palely gleaming waters and indulge – openly and shamelessly in some opinions, unaffectedly in others – in a wide variety of amorous sports and sexual encounters, in positions ranging from the acrobatic to the seductive. The white bodies with their immaterial quality, accented by an occasional black-skinned figure, gleam like rare flowers against the grass and foliage. Behind the gaily coloured fountains and "pleasure pavilions" around the background lake, a soft line of hills modulates the horizon line. However emphatically we may reject the conclusion drawn by Fraenger, namely that Bosch has here visualized the rituals of a heretical secret society, it is nonetheless tempting to concur with his observation that the naked couples are filling the world with natural erotic play, that the sexuality which inspires them appears to be pure joy, pure bliss, and that people have become one with animals and plants in vegetative innocence. Indeed, we might be in the presence of the childhood of the world, the Golden Age described by Hesiod, when men and beasts dwelt in peace together and the earth yielded her fruit abundantly and without effort.

But it would have been a miracle if Bosch exegesis had pronounced itself satisfied with such a verdict. The accepted notion that Bosch's imagination is obsessed with infernal monsters positively demands that his work be interpreted from a more "demonic"angle. And indeed, the apotheosis of innocent sexuality invoked in the central panel is interspersed with numerous irritating factors. Cavorting within this apparently so tranquil "garden", thus the widely held view, is sinful Lust.

This sin presents itself to the voyeuristic viewer in several places within the picture, in what seems a positively perverse fashion: in the couple enclosed in a bubble at the lower left, for example, and in the pair nearby concealed in a mussel shell. Other figures seem engaged in even more "twisted" acts of love, such as the man plunged head first into the water and shielding his privy parts with his hands or, lower right, the youth who thrusts some flowers into the rectum of his companion. Along with these fairly obvious representations, however, the carnal life is also alluded to in metaphorical and symbolic terms. The strawberries that figure so prominently in the landscape – so much so, indeed, that the Spanish called the painting the "Garden of Strawberries" – probably symbolize the fleeting

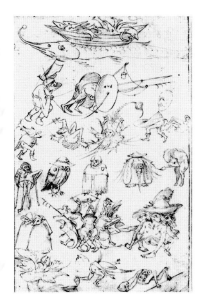

Workshop
Studies of Monsters
Pen and bistre, 31.8 x 21 cm
Oxford, Ashmolean Museum

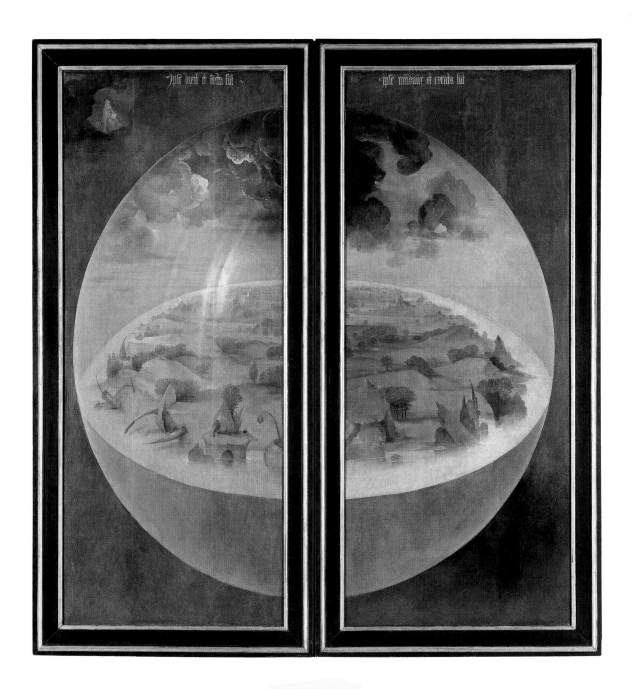

Creation of the World
Outer wings of the *Garden of Earthly Delights*
triptych
Grisaille on panel, 220 x 195 cm
Madrid, Museo del Prado

nature of fleshly pleasure (although within the framework of medieval plant symbolism, strawberries could equally well be interpreted in a positive light, as the food of Paradise). This seems to have been the opinion of Sigüenza, who spoke of the "vanity and glory and transient taste of strawberries", whose "fragrance one can hardly smell when it passes". The Escorial librarian thereby used the word *madroños* to describe the fruit of a plant of the same name. Most modern authors have translated *madroños* without much reflection as "strawberries". In reality, however, the fruit in

question is that of the Strawberry Tree (*Arbutus unedo*), a native of the Mediterranean that can be found growing as far north as Ireland. The fruits of this tree indeed resemble strawberries, but their attractive exterior conceals a bland-tasting flesh. It is possible that the beauty of the figures on the central panel is thus to be interpreted by association as an outwardly pleasing skin surrounding a core made rotten by sexual unrestraint (Unverfehrt*).

A careful study of the *Garden of Earthly Delights* was made several decades ago by Bax**, whose extensive knowledge of earlier Dutch literature enabled him to identify many of the forms in the central panel – fruit, animals, the exotic mineral structures in the background – as erotic symbols inspired by the popular songs, sayings and slang expressions of Bosch's time. For example, many of the fruits nibbled and held by the lovers in the garden serve as metaphors of the sexual organs; the fish that appear twice in the foreground occur as phallic symbols in Old Netherlandish proverbs. According to Bax, the group of youths and maidens picking fruit in the right-hand middle ground also possesses erotic connotations: "to pluck fruit" (or flowers) was a euphemism for the sexual act. Most interesting, perhaps, are the large, hollow fruits and fruit peelings into which some of the figures have crept. Bax sees them as a play on the medieval Dutch word *schel* or *schil*, which signified both the "rind" of a fruit and "quarrel" or "controversy". Thus, to be in a *schel* was to engage in a struggle with an opponent, and this included the more pleasant strife of love. Moreover, the empty rind itself signified worthlessness. Bosch could have chosen no more appropriate a symbol for sin, for it was, after all, a fruit that brought about the fall of Adam.

Is it significant that Bosch should locate his sensual details in a great park or garden-like landscape? The garden had functioned for centuries as a setting for lovers and love-making. The most famous medieval love garden was the one described in the *Romance of the Rose*, a long allegorical poem of the thirteenth century; translated into many languages, including Dutch, it also inspired numerous imitations in later literature and art. Love gardens invariably contain beautiful flowers, sweetly singing birds and a fountain in the centre around which the lovers gather to stroll or sing, as can be seen in many tapestries and engravings of Bosch's day. That Bosch was familiar with this tradition cannot be doubted. In the *Garden of Earthly Delights*, he brings together numerous elements of traditional love-garden iconography, including the fountain and "pleasure pavilions" that dominate the lake in the background. These curiously wrought, glittering forms are, in fact, hardly more fantastic than the fountains and buildings, constructed of gold, coral, crystal and other precious materials, that are described in many literary Gardens of Love.

Although the *Garden of Earthly Delights* thus owes much to conventional love gardens, the inhabitants of the latter generally behave much more discreetly; very seldom do they frisk about naked or make love in the water (the same does not altogether apply to representations of the Fountain of Youth, another highly popular theme of literature and the fine arts at the end of the Middle Ages and start of the Renaissance). Whatever the case, the association of love and love-making with water was firmly established by Bosch's day. In calendar scenes depicting the Labours of the Months, for

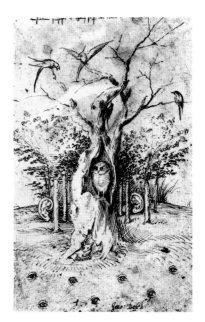

The Hearing Forest and the Seeing Field
Pen and bistre, 20.2 x 12.7 cm
Berlin, Kupferstichkabinett SMPK

* Gerd Unverfehrt: *Wein statt Wasser: Essen und Trinken bei Jheronimus Bosch*, Göttingen 2003, pp. 22ff.

** Dirk Bax: *Beschrijving en poging tot verklaring van het Tuin der onkuisheiddrieluik van Jeroen Bosch, gevolgd door kritiek op Fraenger*, Amsterdam 1956. Another author offering a detailed discussion of popular figures of speech as a source for Bosch's pictorial inventions is Roger H. Marijnissen (op. cit.).

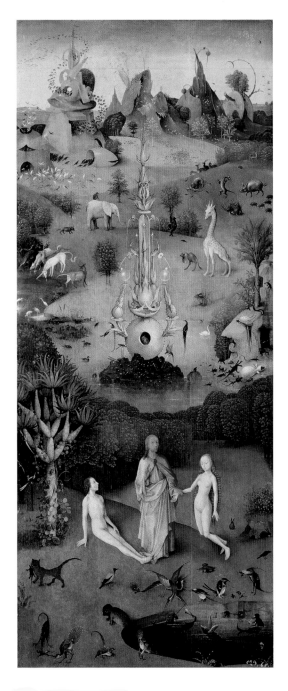

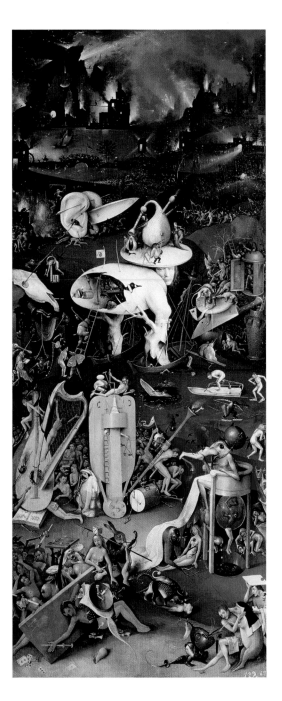

Garden of Earthly Delights (triptych),
1480–90 or c. 1510–16 (?)
Oil on panel, 220 x 389 cm
Madrid, Museo del Prado

LEFT WING:
Paradise (Garden of Eden)
Oil on panel, 220 x 97 cm

RIGHT WING:
Hell
Oil on panel, 220 x 97 cm

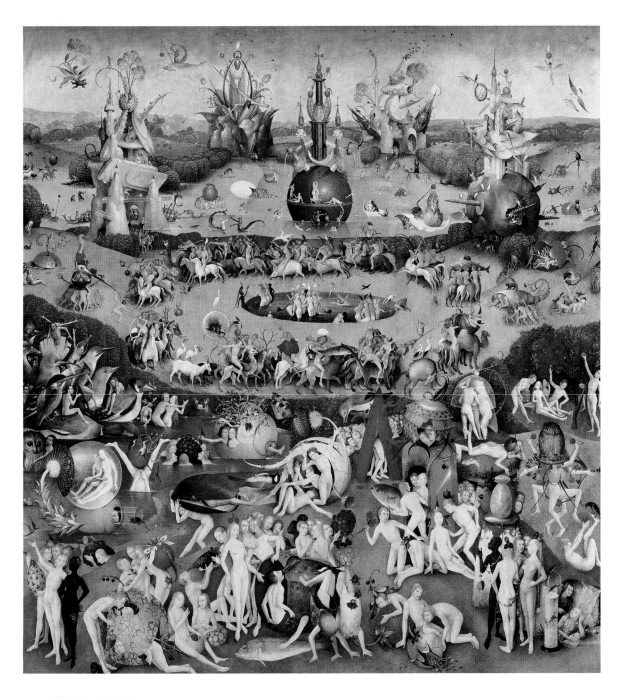

CENTRAL PANEL:
Garden of Earthly Delights
Oil on panel, 220 x 195 cm

Workshop
Tortoise with Death's Head on its Carapace and Winged Demon
Pen and bistre, 16.4 x 11.6 cm (drawing on the verso of the sheet with the *Two Monsters*, p. 57)
Berlin, Kupferstichkabinett SMPK

example, May, the time of love, can be found illustrated by lovers embracing in a tub of water.

According to some art historians, the Garden of Love and the Bath of Venus are joined in the *Garden of Earthly Delights* by a third major theme. Whereas the two sexes can be swimming together in the lake in the background, in the middle ground they are carefully segregated: the women bathing in the pool, the men riding around it. The men's acrobatics – one of the riders is performing a somersault on the back of his mount – have been interpreted by some as a metaphorical equivalent of their physical excitement, as provoked by the presence of the women. Animals often served to symbolize the lower or animal appetites of humankind and personifications of the Sins were frequently depicted on the backs of various beasts: the act of riding, finally, was commonly employed as a metaphor for the sexual act.

A completely different interpretation of the central panel of this triptych was put forward a few years ago by Hans Belting.* According to Belting, Bosch has hidden a contemporary Utopia, as it were, within an imaginary Paradise. The *Garden of Earthly Delights* thereby has nothing to do with any heretical secret document or cleverly coded illustration of the biblical account of Creation, nor with any disparagement of human sexuality or blasphemous voyeurism. Quite the contrary. It visualizes a state of happiness existing on earth, one that the work's intended recipients at the Burgundian court in Brussels were invited to compare with the reports coming back from the recently discovered New World. To many humanists of the early Renaissance, there seemed to have been discovered on the New Continent a world in which the Fall had never taken place, in which people still lived in harmony – including sexual harmony – with Nature, where they procreated and were happy.

This interpretation contains loud echoes of Jean-Jacques Rousseau and the "noble savages" of the eighteenth century, however. It attributes to Bosch a vision that would only be granted literary form in 1516, the year of the artist's death, in the highly influential fictive travel account of *Utopia* composed by the English writer Thomas More. Nor is Belting's basic thesis able to explain every detail of the painting in a truly convincing or indeed even adequate fashion. And yet it transposes the *Garden of Earthly Delights* into an iconographical sphere that seems concordant with the uninhibited lovemaking, the cheerful and gay colours, the bright, clear light, and the physical beauty of most of the people portrayed here.

The scenes on the outer and inner wings present the "counter-world" to this Utopia. On the external shutters, which are painted in a grisaille that subtle incorporates other hues, we look down at the Creation of the world from a cosmic and indeed divine perspective (p. 52). The strangely small figure of the Creator appears in the upper left-hand corner. In the approximately contemporary frescoes of the Sistine ceiling, Michelangelo represented God as a sort of superhuman sculptor imposing form on the primordial chaos with his own hands. Bosch, on the other hand, visualized the act of Creation more closely in line with biblical tradition, according to which God created the world through his Word. The Creator is calmly enthroned and holds a book in his hand, while the divine *fiat* is recorded near the upper edge in an inscription taken from Psalms 33:9: "Ipse dixit et facta sunt, ipse

* Hans Belting: *Hieronymus Bosch: Garden of Earthly Delights*, Munich/Berlin/London/New York 2002.

mandavit et creata sunt." ("For he spoke, and it was done; he commanded, and it stood fast.") Light has been separated from darkness in the centre of the wing, and within the sphere of light, the waters have been divided above and below the firmament. Dark rain clouds gather over the dry land emerging slowly from the misty waters beneath. Already trees are sprouting from its humid surface, as well as curious growths, half-vegetable, half-mineral, which anticipate the exotic flora of the inner panels. This is the earth as it stood on the third day of creation. The disc-shaped Earth (it had long been known that the earth was round when the triptych was painted) is still protected, as it were, within a glass sphere (its curvature indicated by reflections of the light), but the sombre palette dominating the entire subject does not necessarily hold the promise of a happy future for the world.

On the inside of the left wing, the greyish-brown tones give way to brilliant colour and the last three days of Creation are accomplished. Land and water have brought forth their swarms of living creatures, including a giraffe, an elephant, and some wholly fabulous animals, like the unicorn. In the centre rises the Fountain of Life, a tall, slender roseate structure resembling a delicately carved Gothic tabernacle. The precious gems glittering in the mud at its base and some of the more fanciful animals probably reflect the medieval descriptions of India, whose marvels had fascinated the West since the days of Alexander the Great and where popular belief situated the lost paradise of Eden.

In the foreground of this antediluvian landscape, we see not the Temptation and Expulsion of Adam and Eve, as in the *Haywain*, but their union by God. Taking Eve by the hand, he presents her to the newly awakened Adam who gazes at this creation from his rib with a mixture, it seems, of surprise and anticipation. God himself is much more youthful than his white-bearded counterpart on the outer wings, and represents the Deity in the guise of Christ, the second person of the Trinity and the Word of God made incarnate (John 1:14). The marriage of Adam and Eve by a youthful Deity occurs frequently in Dutch manuscripts of the fifteenth century, and illustrates the moment when he blessed them, saying in the words of Genesis 1:28: "Be fruitful and multiply."

Divine blessing is not all that lies over this paradise, however. Contrary to the account in Genesis, the law of eat or be eaten is also present in this seemingly trouble-free idyll. In the foreground, in particular, some of the beasts depicted on a miniature-like scale are caught up in the struggle for existence that will become the fate of the world and Nature after the Fall. The cruelty and evil, the hacking, stabbing and killing that lead the majority of humankind not just to physical but also to moral ruin, also lead to the infernal court of justice, whose horrors are detailed on the inside of the right wing opposite. Here, the Aphroditean dream world of the central panel gives way to the reality of the nightmare. It is Bosch's most exalted vision of Hell. Buildings do not simply burn; they explode into the murky background, their fiery reflections turning the water below into blood. In the foreground a rabbit carries his bleeding victim on a pole, a motif found in other of Bosch's Hell scenes, but this time the blood spurts forth in a fountain from the belly. The hunter who has become the prey well expresses the chaos of Hell, where – measured against the normality of earthly life – relationships are turned upside down. This is even more dramatically conveyed in the in-

Bosch school
Two Monsters
Pen and bistre, 16.4 x 11.6 cm
Berlin, Kupferstichkabinett SMPK

Nest of Owls
Pen and bistre, 14 x 19.6 cm
Rotterdam, Museum Boijmans Van Beuningen

nocuous everyday objects that have swollen to monstrous proportions and serve as instruments of torture; they are comparable to the oversized fruits and birds of the central panel. One nude figure is attached by devils to the neck of a lute; another is helplessly entangled in the strings of a harp, while a third soul has been stuffed down the neck of a great horn. On the frozen lake in the middle ground, a man balances uncertainly on an oversized skate, and heads straight for the hole in the ice before him, where a companion already struggles in the freezing water. This episode echoes old Dutch expressions similar in meaning to the English "skating on thin ice", indicating a precarious situation indeed. Somewhat above, a group of victims have been thrust into a burning lantern that will consume them like moths, while on the opposite side, another soul dangles through the handle of a door key. Behind, a huge pair of ears advances like some infernal army tank, immolating its victims by means of a great knife.

The focal point of Hell, occupying a position analogous to that of the Fountain of Life in the Paradise wing, is the so-called Tree Man, whose egg-shaped torso rests on a pair of rotting tree trunks that end in boats for shoes. His hind quarters have fallen away, revealing a hellish tavern scene within, while his head supports a large disc on which devils and their victims promenade around a large bagpipe. The face looks over one shoulder to regard, half wistfully, the dissolution of his own body. A similar, though less forcefully conceived, *Tree Man* was sketched by Bosch in a drawing now in the Vienna Albertina (p. 6). The meaning of this enigmatic, even tragic figure has yet to be explained satisfactorily, but nowhere would Bosch more successfully evoke the shifting, insubstantial quality of a dream than in this image, one that has been countlessly copied and paraphrased.

Considerably more solid, in contrast, is the bird-headed monster in the lower right-hand corner, who gobbles up the damned souls only to defecate them into a transparent chamber pot from which they plunge into a pit below (p. 59). He recalls a monster in the *Vision of Tundale* who digested the souls of lecherous clergy in a similar manner. Other sins can be identified in the area around the pit. The slothful man is visited in his bed by demons, and the glutton is forced to disgorge his food, while the proud lady is compelled to admire her charms reflected in the backside of a devil. Lust, like Avarice, was thought to give rise to other deadly vices: indeed, as the first sin committed in the Garden of Eden, it was often considered the queen and origin of all the rest. The knight brought down by a pack of hounds to the right of the Tree Man is most likely guilty of the sin of Anger, and perhaps also of Sacrilege, for he clutches a eucharistic chalice in one mailed fist, as does the nude astride a cow in the *Haywain*. The tumultuous group below right suffers for the excesses associated with gambling and taverns.

Again and again, however, we encounter references to Lust. It is punished in the lower right-hand corner, where an amorous sow wearing a nun's headdress tries to persuade her similarly naked lover to sign a document in his lap. An armoured monster waits nearby with an inkwell dangling from his beak. Lust is also the subject of the oversized musical instruments and choral singing in the left foreground. These scenes, as well as the bagpipe on the head of the Tree Man, have been interpreted as a blast against travelling players who frequented the taverns and whose lewd songs stirred others to lechery. But the musical instruments themselves often possessed erotic

Bird-headed Monster
Detail of the left wing of the *Garden of Earthly Delights* (cf. p. 54)
Madrid, Museo del Prado

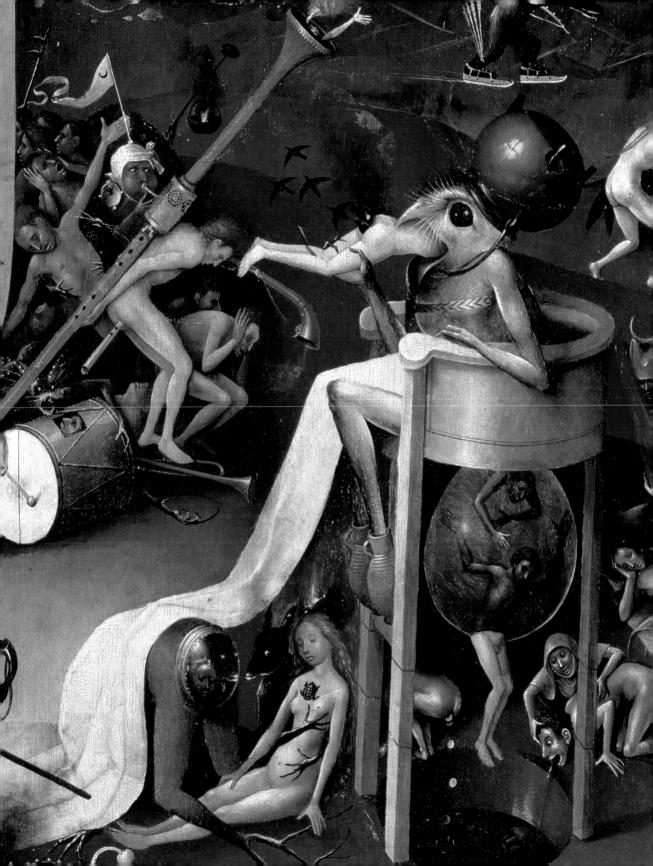

Bosch imitator (also attributed to Pieter Bruegel the Elder)
Beggars
Pen and bistre, 28.5 x 20.5 cm
Vienna, Albertina

connotations. The bagpipe, which Brant calls the instrument of dunces, also figured as an emblem of the male organ of generation, while to play the lute signified making love. Medieval moralizers also frequently described lust as a "music of the flesh", a concept also reflected in the long-snouted musician who serenades the lovers in the Prado *Haywain*. It is a discordant music, contrasted to the harmonies of the divine order.

The *Garden of Earthly Delights* is undoubtedly Bosch's masterpiece. In no other work did the master from 's-Hertogenbosch display the same complexity of thought in such vivid images. It is for this reason, more than any other, that we may place this triptych fairly late in Bosch's career, certainly well after 1500. The history of the world that is presented here as Christian fact, and which perhaps extends to a vision of Utopia, harbours the same universality that was radiated by the sculptural programmes on Gothic cathedral façades and was staged in the contemporary cycles of mystery plays. Bosch's triptych also reflects the Renaissance love of highly original ideas and complex allegories whose full meaning was apparent only to a limited audience. The particular nature of the subject of the *Garden of Earthly Delights*, and indeed also of the *Haywain*, make it unlikely that they were destined for a church or monastery, but rather for high-ranking lay patrons. There is good evidence, in fact, that the *Garden of Earthly Delights* was commissioned by Hendrik III of Nassau. Other Burgundian nobles are also documented as owning works by Bosch. The Flemish literati who met in circles of rhetoric and the members of court society in Brussels and Malines possessed a taste for intellectual puzzles, especially those of a moralizing nature. It is not difficult to imagine that this milieu would have been particularly enthusiastic about Bosch's art.

The Pilgrimage of Life

The *Haywain* and the *Garden of Earthly Delights* – this latter in the paintings on its wings, at least – show humankind trapped by its age-old enemies, the World, the Flesh and the Devil. The precarious situation of the human soul in this life was portrayed again, although in somewhat different terms, on the exterior shutters of the *Haywain* triptych (p. 62). When in the closed position, these outer wings form a single composition whose painting is inferior in quality to the inside of the triptych and therefore was probably completed by workshop assistants. The composition, however, is attributed to Bosch himself.

The foreground is occupied by an emaciated, shabbily dressed man who is no longer young, carrying a wicker basket strapped to his back. He travels through a menacing landscape: a skull and several bones lie scattered in the lower left-hand corner, an ugly cur snaps at his heels, while the footbridge on which he is about to step appears very fragile indeed. In the background, bandits have robbed another traveller and are binding him to a tree, and peasants dance on the right to the skirl of a bagpipe. A crowd of people gather around an enormous gallows in the distance, not far from a tall pole surmounted by a wheel, used for displaying the bodies of executed criminals.

A countryside similarly filled with violence extends behind St James the Great on the exterior of the Vienna *Last Judgement* (p. 34), serving to remind us that St James – also known as St James of Compostella – was the patron saint of pilgrims, who invoked his protection against the dangers of the road. According to the spiritual thinking of the Middle Ages, based above all upon the writings of the church father St Augustine, in principle every man was a pilgrim on earth, an exile searching for his lost homeland.

The pilgrim on the outer wings of the *Haywain* appears as a morally neutral figure, neither good nor bad. The dangers that threaten him come from the outside world, whose vicissitudes are represented in the landscape. Some of these dangers are physical, such as the robbers or the snarling dog, although the latter may also symbolize detractors and slanderers, whose evil tongues were often compared to barking dogs. The dancing peasants, however, connote a moral danger; like the lovers on top of the haywain, they have succumbed to a music that arouses the desires of the flesh. In expressing the spiritual predicament of all humankind, the pilgrim thus resembles Everyman and his Dutch and German counterparts Elckerlijc and Jedermann, whose spiritual pilgrimages formed the subject of contemporary morality plays.

A few years later, Bosch reworked the figure of this pilgrim in an unforgettable circular painting today in Rotterdam, *The Wayfarer* (p. 65). This tondo (now set into an octagonal frame) is composed of two separate panels that

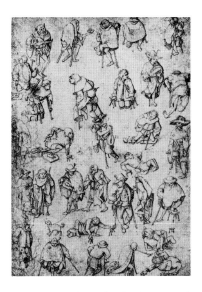

Bosch imitator (also attributed to Pieter Bruegel the Elder)
Beggars and Cripples
Pen and bistre, 26.4 x 19.8 cm
Brussels, Bibliothèque Royale Albert I,
Cabinet des Estampes

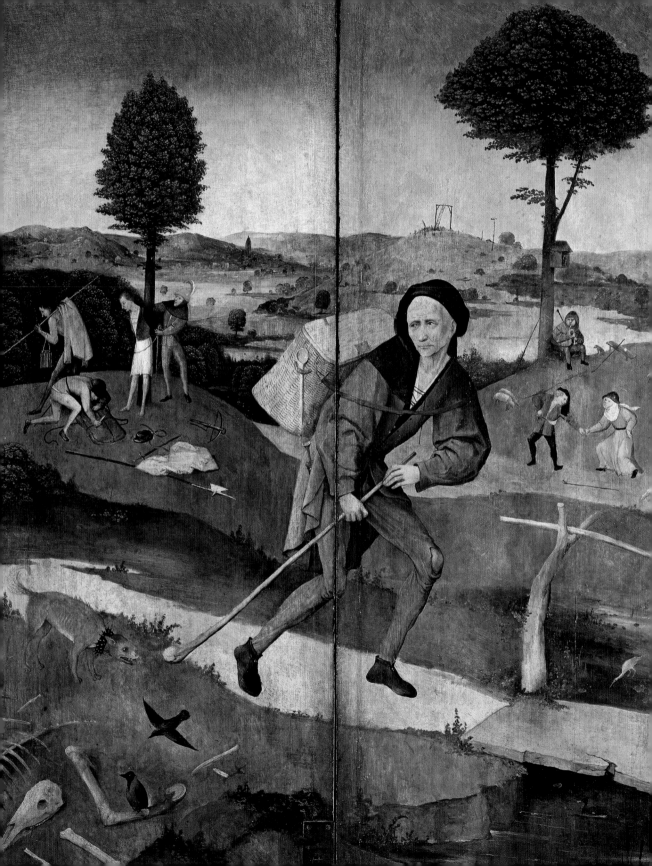

were once the tall exterior wings of a triptych. The wayfarer is depicted against one of the most beautiful and most delicate landscapes that Bosch ever painted. The rolling sand dunes on the right and the subdued tonalities of grey and yellow are sensitive transcriptions into paint of the rain-drenched Dutch countryside. There is fundamentally no need to anchor the motif, as some scholars have done, in the biblical parable of the Prodigal Son. The tattered foreground figure closely recalls the pilgrim in the *Haywain*, except that he appears even more haggard and poorly dressed. There are, however, some subtle differences. Except for the snarling dog, with its possible allusion to slander, the chief dangers posed by the outside world are here moral and spiritual in nature. They are embodied first of all in the tavern on the left, whose ruinous condition echoes the ragged clothes of the wayfarer. As in Bosch's earlier *Marriage Feast at Cana*, the tavern symbolizes the World and the Devil in general; the particularly dubious nature of the present establishment is signified by the man urinating on the right, and by the couple embracing in the doorway. Another inmate of the house peers curiously through one of the dilapidated windows.

The customer for whom the second woman waits may very well be the dilapidated wayfarer himself, whom some interpretors see simply as a peddlar. As Bax has perceptively observed, he has not just emerged from the tavern, but has passed it in his journey and now halts on the road, as if allured by its promise of pleasure. Bax further suggests that the garments of the traveller and the various articles he carries are a symbolic commentary on his poverty, on the sinful tendencies that led to his present condition, and on his readiness to succumb to temptation once more. And indeed, Bosch has transformed the defensive movement of the *Haywain* pilgrim into an attitude of hesitation, while the wayfarer's head is turned towards the tavern with a sad, almost wistful expression.

Bosch may not state the moral alternatives quite so explicitly in the Rotterdam tondo, but they are discernible nonetheless. Although the wayfarer is glancing back, as we have said, in the direction of the tavern, his path leads to a gate that will admit him to the tranquil Dutch countryside beyond. Unlike the violence-filled landscape of the *Haywain* wings, the background contains no suspicious incidents and, except for the owl perched on a dead branch directly above the wayfarer's head (and which might signal the virtues of Prudence and Wisdom rather than carry a pejorative meaning), no overt symbols of evil. We are probably justified in seeing in the gate and fields a moment of spiritual homecoming, a reference to Christ, who says of himself: "I am the door. If anyone enters by Me, he will be saved, and go in and out and find pasture" (John 10:9).

Art historians are fairly confident that the circular painting, once a component of the outer wings of a triptych, formed part of a retable that, in the open position, revealed the *Ship of Fools* in the Louvre (p. 29) and the *Allegory of Gluttony* and *Lust* in New Haven (p. 31) on its left wing, and the *Death of the Miser* in Washington, DC (p. 32), on its right wing, accompanied by a lost central panel.

A profoundly pessimistic world view characterizes the decoration of a pair of panels – possibly the wings of a former polyptych – also housed in Rotterdam (pp. 66–67). On the reverse, Bosch arranged four small mono-chrome scenes showing humankind beset by devils. These evil spirits possess

The Wayfarer
(The Peddlar)
Outer wings of the *Haywain* triptych
Oil on panel, 135 x 90 cm
El Escorial, Monasterio de San Lorenzo

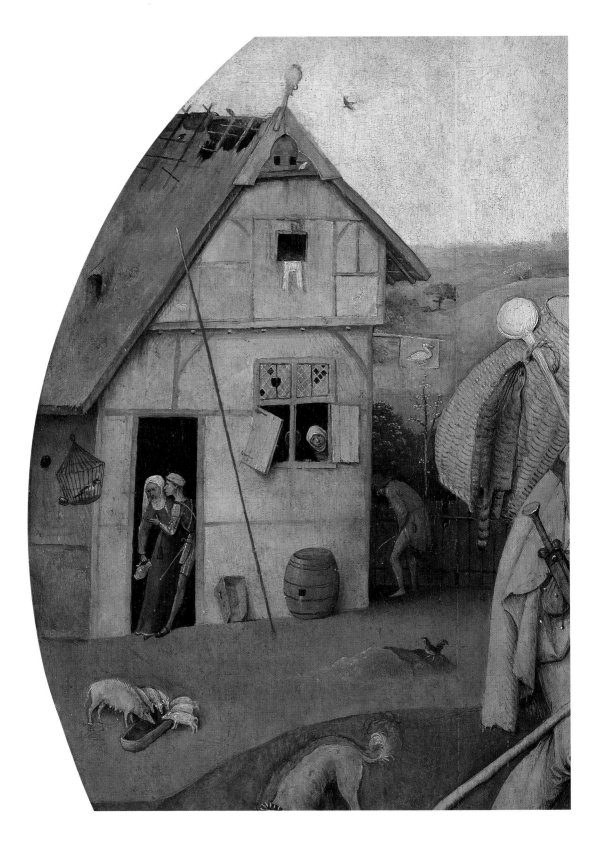

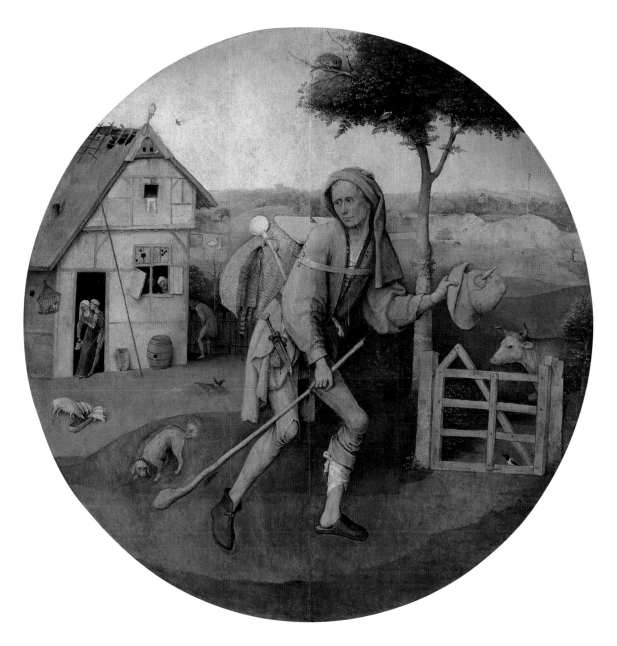

a farm and drive away the inhabitants, throw a ploughman from his horse and fall upon an unwary traveller. In the fourth scene, however, the Christian soul finds asylum: he kneels before his heavenly Lord while a companion, like the just souls described in the Revelation of St John 6:11, receives a white robe from an angel.

Although the fear of the Devil continued to flourish throughout the entire Middle Ages, it reached a particularly extreme height in Bosch's lifetime. Erasmus of Rotterdam, the greatest humanist thinker of the period around 1500, may have been able to scoff at the demons of hell as mere bogeymen and empty illusions from his position of enlightened spirituality, but most of

The Wayfarer (tondo)
(The Prodigal Son), c. 1494 or later
Oil on panel, diameter 71.5 cm
Rotterdam, Museum Boijmans Van Beuningen

The House of Ill Repute
Detail of *The Wayfarer*

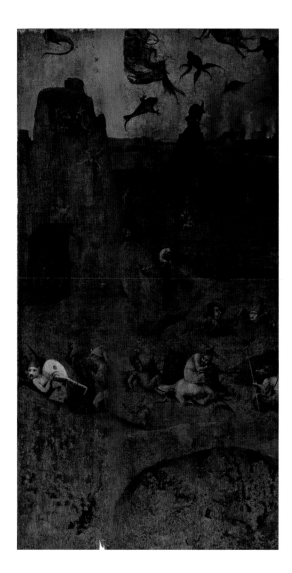

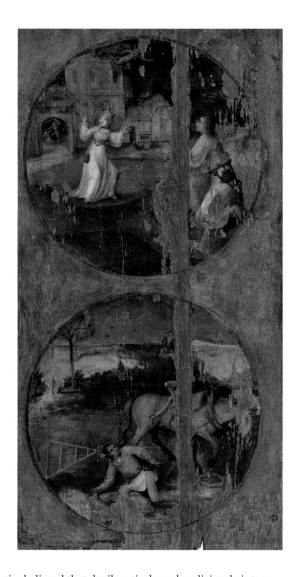

Two wings of a triptych with scenes of **Hell** and
The Flood
(each wing with two medallions of biblical
scenes or parables on the reverse), c. 1514 or later
Rotterdam, Museum Boijmans Van Beuningen

LEFT WING:
Fall of the Rebel Angels
Oil on panel, 69 x 36 cm

REVERSE:
Mankind Beset by Devils
Oil on panel, diameter 32.4 cm (each)

Bosch's contemporaries believed that devils actively and maliciously intervened in human affairs, both directly and through their agents, namely witches and sorcerers. These beliefs were codified in the infamous *Malleus Maleficarum* first published in Nuremberg in 1494. Authored by the Dominicans Jacob Sprenger and Heinrich Kramer (Heinrich Institoris), this "Witches' Hammer" described in scholastically precise terminology (at the same time greedily following the trail of every possible sexual perversion using the most perfidous methods of investigation) the alleged nature of witches and their relationships with the Devil, as well as the ways by which they were to be recognized and suitably punished. The *Malleus Maleficarum* appeared in dozens of editions and possibly provided the inspiration for the scenes on the obverse of the pair of panels in Rotterdam – although this does not mean that we should see Bosch as an advocate of witch torture and burning. The medallions show the Rebel Angels, already transformed into monsters, tumbling into a desolate landscape; and the landing of Noah's Ark

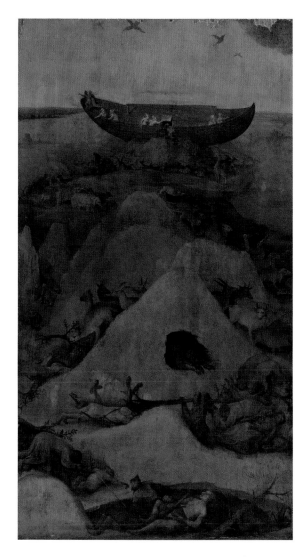

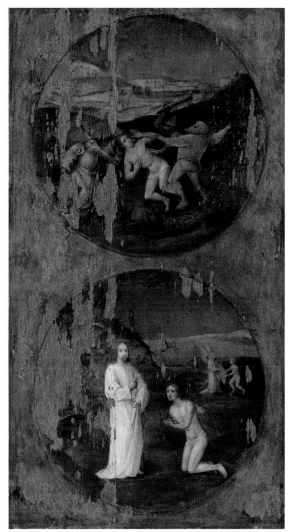

on Mount Ararat, from which animals descend by pairs among the corpses of the drowned.

To Bosch's contemporaries, the melancholy spectacle of sin and folly could be explained only in terms of the Devil and his followers seeking to lead humankind to perdition. Against such overwhelming odds, what chance did the pilgrim have of reaching his homeland? The answer of the medieval Church may be summed up in the title of Thomas à Kempis's book the *Imitation of Christ*. By renouncing the world and following the examples set by Christ and his saints, the pilgrim could hope to pass through the dark night of this world into Paradise. And although Bosch painted many pictures mirroring the tragic condition of humanity, he produced almost as many others that illuminated this path to salvation.

RIGHT WING:
Noah's Ark on Mount Ararat
Oil on panel, 69.5 x 38 cm

REVERSE:
Mankind Beset by Devils
Oil on panel, diameter 32.4 cm (each)

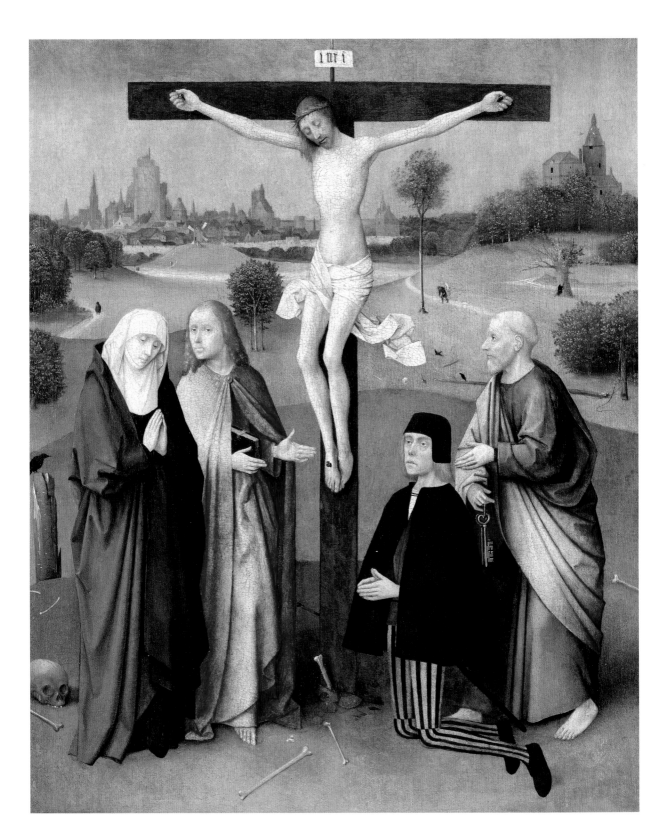

The Imitation of Christ

Although Bosch contributed many new themes to Netherlandish painting, it must be remembered that well over half of his pictures are devoted to traditional Christian subjects: the lives of the saints and the life of Christ, especially episodes from the Passion. As might be expected, many of his Christological scenes are fairly conventional, conforming to iconographical types that had been current in central Europe for several generations. Bosch surpasses these forerunners, however, in intensity of expression and scenographic composition. This is true, as we have seen, of works such as the Philadelphia *Adoration of the Magi* and the Frankfurt *Ecce Homo*. In his treatments of *Christ Carrying the Cross*, he occasionally depicts the good thief confessing to a friar or priest, as we have also already observed, but this anachronism was simply a logical development of the late medieval custom of clothing sacred history in contemporary modes and manners. Several of Bosch's paintings imply a familiarity with Flemish painting, although without being directly dependent upon it, to be sure, or falling into its school. His *Nativity*, for example, now lost but represented by a good copy in Cologne, reflects the compositions of Hugo van der Goes, whose influence is also to be seen in several Passion scenes discussed below. The Brussels *Crucifixion with Donor* (p. 68), a compositionally fairly rule-abiding votive panel sadly today in very poor condition, likewise suggests the influence of Dirk Bouts and his followers, or alternatively – according to other authors – that of Rogier van der Weyden, although Bosch has characteristically transformed the conventional distant view of Jerusalem into the homely forms of a simple Dutch town, perhaps 's-Hertogenbosch itself, veiled in atmospheric greys and lavenders. The identity of the donor in the strikingly striped hose has yet to be uncovered.

In a number of important instances, however, Bosch transcended the limits of the biblical narrative to present a more universal image of the conflict between good and evil. This has already been observed in the devil-haunted tavern, which serves as a setting for the early *Marriage Feast at Cana* (p. 23), and van Mander describes a *Flight into Egypt*, now lost, whose landscape contained an inn similarly possessed by demons. This idea also inspired one of Bosch's most enigmatic works, the *Adoration of the Magi* triptych in the Prado (pp. 70–71).

The inner wings of this altarpiece are occupied by the kneeling figures of the donors, a man and a woman, attended by their patron saints Peter and Agnes. The coats of arms behind them identify the pair as members of the Bronckhorst and Bosshuyse families; unfortunately, however, these names have not brought us any closer to establishing the date of the work or its original destination.

Bosch's circle
Christ Carrying the Cross
Pen, 23.6 x 19.8 cm
Rotterdam, Museum Boijmans Van Beuningen

Crucifixion with Donor, c. 1483 or later
Oil on panel, 70.5 x 59 cm
Brussels, Musées Royaux des Beaux-Arts

The central panel, which art lovers have always considered one of the most beautiful of Bosch's works, shows in the foreground the adoration of the Christ Child by the Three Kings. Many details of the composition, including the ruined stable and the sumptuous dress of the Magi, bring to mind Bosch's *Adoration* in Philadelphia (p. 13), but the intimate mood of the earlier version has completely disappeared. Instead of reaching out impulsively towards the kings, the Infant Christ now sits solemnly enthroned on his mother's lap. The Virgin, too, has acquired a new dignity and inner amplitude. Set apart from the other figures by the projecting roof of the stable, the Virgin and Child resemble a self-contained devotional image beneath its baldachin, and the Magi approach with all the gravity of priests in a religious ceremony. The splendid crimson mantle of the kneeling king provides a formal counterpart to the monumental figure of the Virgin. That Bosch intended to show a parallel between the homage of the Magi and the celebration of the Mass is clearly indicated by the gift that the oldest king has placed at the feet of the Virgin: it is a small sculptured image of the Sacrifice of Isaac, a prefiguration of Christ's sacrifice on the Cross. Other Old Testament episodes are illustrated on the elaborate cape worn by the second king, which shows the visit of the Queen of Sheba to Solomon, and on the Moorish king's silver orb, depicting Abner offering homage to David. In the *Biblia Pauperum* or "Paupers' Bible", a popular religious picture book of the period, both scenes are presented as Old Testament forerunners of the Epiphany and are depicted beside the illustration of the Adoration of the Magi.

A group of peasants have gathered around the stable on the right. They peer from behind the wall with lively curiosity and scramble up to the roof in order to get a better view of the exotic strangers. Although the shepherds had already come to see the new-born Christ on the night of his birth, in the fifteenth century they frequently reappear as spectators at the Adoration of the Magi. Generally, however, they thereby show much greater reverence than that displayed by Bosch's peasants, whose nonchalance contrasts strongly with the dignified bearing of the Magi. This difference is significant, for the shepherds were frequently identified with the Jews who rejected Christ, while the Magi represent the Gentiles who accepted him as the true Messiah.

The most curious detail of Bosch's Adoration scene is the man standing just inside the stable behind the Magi and thereby displaying the elegant curve of his leg in an almost flirtatious manner. Naked except for a thin shirt and a crimson robe gathered around his loins, this bearded figure wears a turban-like headdress; a gold bracelet encircles one arm, and a transparent cylinder covers a sore on his ankle. He regards the Christ Child with an ambiguous smile, but the faces of several of his companions appear distinctly hostile.

These figures, who range from the extravagant to the grotesque, have attracted a host of interpretations. The fact that they are standing within the dilapidated stable – a time-honoured symbol of the Synagogue – has led them to be identified as Herod and his spies, for example, or as the Antichrist and his counsellors. Although neither of these identifications is quite convincing, the association of the chief figure with the powers of darkness is clearly suggested by the demons embroidered on the strip of cloth

Adoration of the Magi (Epiphany)
(triptych), 1485–1500 or c. 1510
Oil on panel, 138 x 138 cm
Madrid, Museo del Prado

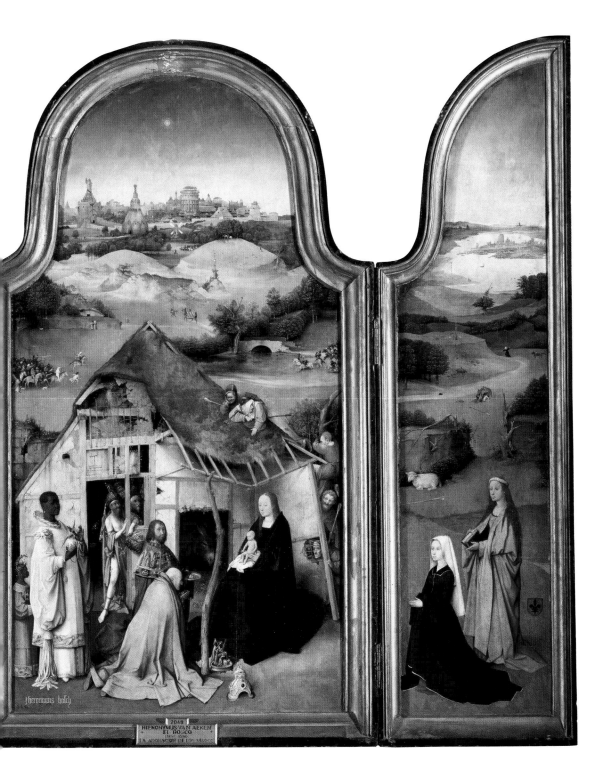

LEFT WING:
Male Donor with St Peter and Joseph
Oil on panel, 138 x 33 cm

CENTRAL PANEL:
Adoration of the Magi
Oil on panel, 138 x 72 cm

RIGHT WING:
Female Donor with St Agnes
Oil on panel, 138 x 33 cm

The Mass of St Gregory
Outer wings of the *Adoration of the Magi*
triptych
Grisaille on panel, 138 x 66 cm
Madrid, Museo del Prado

Christ Carrying the Cross
Oil on panel, 150 x 94 cm
El Escorial, Monasterio de San Lorenzo

hanging between his legs. A row of similar monsters can be seen as decoration on the large object that he holds in one hand; surprisingly, this can only be the helmet of the second king, and still other monsters decorate the robes of the Moorish king and his servant. These demonic elements may possibly refer to the pagan past of the Magi and to the medieval belief that the kings had practised sorcery before their conversion to Christ.

The stable and its inhabitants seem to be the source of the malevolent forces contaminating almost every part of the majestic panoramic landscape that unfolds coherently across the background of all three panels – an extremely modern touch. Demons haunt the ruined portal building in the left wing, where Joseph sits alone, hunched over a fire, beneath a ramshackle roof. The crumbling walls around him are the remains of King David's palace, near which the Nativity was popularly supposed to have occurred; like the dilapidated stable, it represents the Synagogue, the law of the Old Covenant losing its validity with the birth of Christ and thus the advent of the New Covenant. In the field behind, the tiny figures of peasants dance to the sound of bagpipes, a familiar symbol of the carnal life. On the right wing, wolves attack a man and a woman on a desolate road. Behind the stable in the centre, the followers of two of the Magi rush towards each other like opposing armies; the host of the third king – who like his royal companions had come prepared to cross the whole world by force and fight anyone who wished to oppose him, according to a saying of 1487 – appears beyond the sand dunes. The gently rolling countryside contains, in addition, an abandoned tavern and a pagan idol. Even the distant grey-blue walls of Jerusalem, one of Bosch's most evocative renderings of the Holy City, appear vaguely sinister. A little roadside cross leans precariously to one side on the left, and the two watchtowers are architecturally similar to the demonic city that Bosch depicted in the *Temptation of St Anthony* triptych in Lisbon (pp. 91–95).

The *Adoration of the Magi* has for centuries been seen in close symbolic association with the Mass. Just as the incarnate Christ appeared to the shepherds and the Magi, so does he continue to appear to the faithful in the form of the bread and wine. In the Philadelphia *Adoration*, Bosch had alluded to the Eucharist by depicting on the sleeve of the Moorish king the Gathering of Manna by the Jews, an episode considered a prefiguration of the Last Supper in Christian exegesis. The relationship between Epiphany and Eucharist, however, is more explicitly stated on the outer wings of the Prado triptych, which, when closed, display *The Mass of St Gregory* (left). The tall, narrow panels are painted in a greyish-brown monochrome, except for the two male donors, who are rendered in a naturalistic palette. It is possible that they represent a father and son, but in terms of facial resemblance neither can be equated with the worthy patrician on the inside of the left wing.

The legend of the Mass of St Gregory tells the story of a eucharistic miracle that, admittedly, was only attributed to Pope Gregory the Great (c. 540–604) in the late Middle Ages. One day, so we are told, when Gregory was celebrating Mass, one of his acolytes doubted the true and corporeal presence of Christ in the Host. Christ heard the Pope's prayer for some sign from Heaven to refute the unbeliever and appeared on the altar, displaying his wounds and surrounded by the instruments of his Passion. Bosch accentuates this miracle as a spiritual dialogue between the kneeling Pope and the

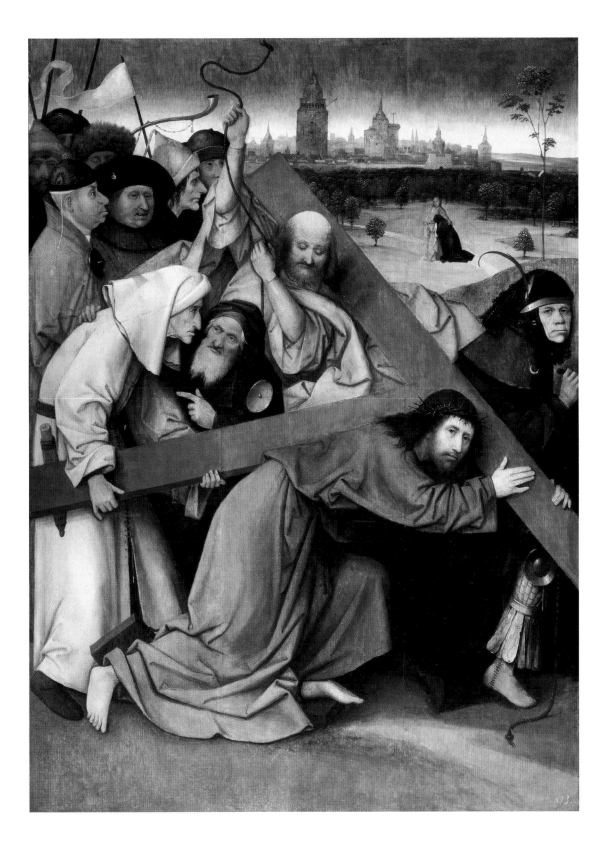

Man of Sorrows emerging from the sarcophagus above, unnoticed by the spectators behind the altar but sensed, if not actually seen, by the acolyte and the two donors.

The basic elements of this composition – the frontal placement of the altar parallel to the pictorial plane, the sarcophagus occupying the centre of the composition and the arched altarpiece shifting strangely from architectural surround to landscape setting – were probably inspired by an engraving that Israhel van Meckenem made in the 1480s. Bosch, however, achieved a monumentality absent in his model by lowering the viewpoint and by increasing the distance between Gregory and his vision of Christ; in addition, he showed not the instruments of the Passion (the *arma Christi*) as we might expect to see them, but the biblical episodes in which each instrument played its role in Christ's martyrdom. Beginning with the Agony in the Garden and the Betrayal, these epidoses unfold in pictures painted on the two lower sides of the arch. Where the arch reaches its apex, however, it transforms itself into Calvary Hill. At the same time, the church interior gives way to an atmospheric open-air backdrop with the Crucifixion scene rising against it. Gregory's vision thus fills the entire church: spreading out in the place of a ceiling vault is a cloudy night sky from which an angel descends to receive the soul of the good thief. In a gruesome departure from traditional iconography, the crucifixion of the bad thief has been replaced by the suicide of Judas Iscariot, whose limp figure dangles from a tree on the right-hand slope, his soul borne away by a black devil. In this detail, Bosch alludes once again to the conflict between Church and Synagogue, reminding us that it was Judas's treachery that precipitated the events of the Passion and the death of Christ.

By comparison with the Prado *Adoration of the Magi*, whose iconographical complexities are exceeded only by the *Garden of Earthly Delights* and the Lisbon *Temptation of St Anthony*, the Passion scenes that Bosch painted during his middle and later years are simpler, their imagery more easily grasped by the viewer. One such work is the *Christ Carrying the Cross* in the Monasterio de San Lorenzo in El Escorial (p. 73). Christ dominates the foreground, almost crushed beneath the heavy Cross, which the elderly Simon of Cyrene struggles to lift from his back. The ugly heads of his executioners rise steeply in a mass towards the left; in the distance, the sorrowing Virgin collapses into the arms of St John the Evangelist. Whereas Bosch's earlier composition of this subject in Vienna (p. 19) had adopted a broader narrative focus, the Madrid version takes a concentrated look at its subject. The fact that Christ ignores his captors to address his gaze wholly at the spectator lends the composition the suggestive power of a timeless devotional image.

Perhaps, as some critics claim, Bosch equated the historical tormentors of Christ with humankind as a whole, whose daily wickedness will continue to torture Christ for as long as the world endures.

Simon of Cyrene had been compelled by the soldiers to take up the Cross of Christ, but for centuries the Cross had been willingly embraced by pious Christians who sought to emulate the Saviour in their own lives. To imitate Christ was to submit to the assaults of this world with the same patience and humility displayed by Christ himself during his Passion; for temporal affliction, as moralizers and mystics, including those such as Thomas à Kempis, never tired of telling their audience, purifies the soul just as fire tempers steel

Christ Mocked (The Crowning with Thorns),
c. 1485 or later
Oil on panel, 73.7 x 58.7 cm
London, National Gallery

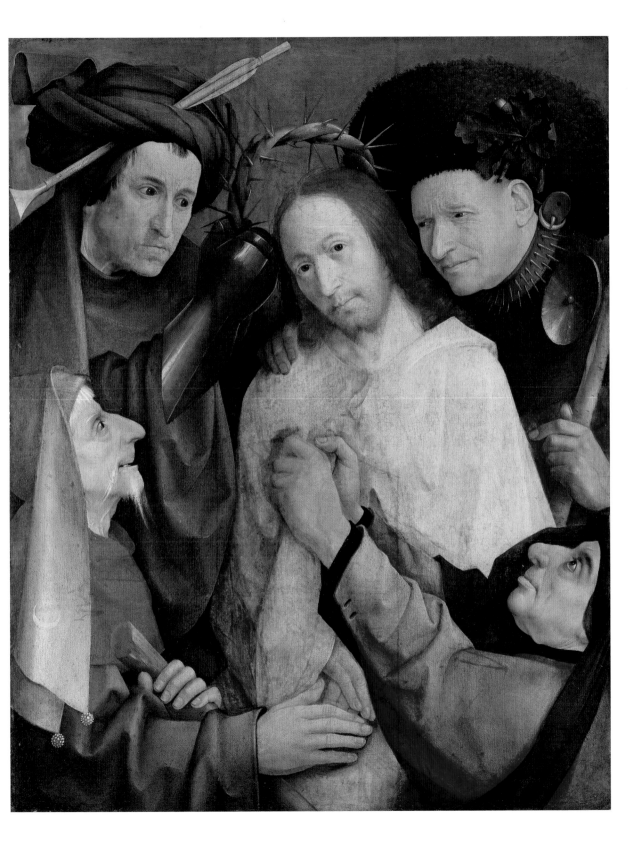

Netherlandish or Austrian artist
Virgin and St John at the Foot of the Cross,
c. 1440
Brush, 30.3 x 17.3 cm
Dresden, Kupferstichkabinett

and refines gold. The concept of the Way of the Cross and the Imitation of Christ was further developed by Bosch in a group of Passion scenes of half-length figures. The earliest panel in this series is most likely the *Christ Mocked (The Crowning with Thorns)* in London (p. 75), whose authenticity has at times been called into question, although such doubts are probably misplaced. The large, firmly modelled figures are composed with the utmost simplicity against the plain, grey-blue background. The four tormentors surround the white-robed Christ as if forming a circle of doom. One soldier holds a crown of thorns above Christ's head, another tugs at his robe and a third, with the facial features of a billy goat, touches his hand in a mocking gesture. Their actions, however, seem curiously ineffectual and, as in the Madrid *Christ Carrying the Cross*, Christ ignores his persecutors to look calmly, even gently, at the spectator.

The half-length format, and the tendency to crowd the figures against the picture plane with little indication of space, are characteristics that reflect a Flemish devotional type popularized by Hugo van der Goes and Hans Memling. Like its Flemish models, the London *Christ Mocked* presents the sacred scene not in its historical actuality but in its timeless aspect, in this instance, as a prototype for the Christian virtues in the midst of adversity.

Bosch's interpretation of the Imitation of Christ must have appealed to his contemporaries, for he went on to produce a second version of *Christ Crowned with Thorns* that substantially modified the London composition and subsequently became the object of numerous copies – another testimony to the popularity of Bosch's pictorial invention. This second panel, today in the Escorial, is impressively large in format. The half-length figures have been adjusted to a circular field and placed against a gold ground (p. 77). Christ's eyes once again engage the viewer. This time, however, his furrowed brow clearly expresses his suffering, and the static gestures of his captors in the earlier version have been transformed into brutal expressions of fury. A snarling rat-faced man rips off Christ's robe with a mailed fist; his smirking companion has placed one foot on the ledge in order to push the crown of thorns more tightly on his head, while a third man watches intently from over his shoulder. In contrast, the two spectators on the left look on with cool detachment. This torment of Christ is given cosmic meaning in the grisaille border, where angels and devils are locked in unending conflict.

The malice of Christ's enemies reaches a hysterical pitch in Bosch's last Passion scene, the *Christ Carrying the Cross* in Ghent (p. 78). This time, Christ is accompanied by St Veronica, an apocryphal figure not mentioned in the Bible, who supposedly wiped the sweat from her Saviour's face as he struggled beneath the Cross and thereby obtained a miraculous image of his features on her handkerchief. The two thieves appear on the right. Around these four figures surge a howling mob who scowl, leer and roll their eyes at their victims, their twisted and deformed faces glowing with an unearthly phosphorescence against the dark foil of the background. These are not men but demons, perfect incarnations of all the lusts and passions that ever stained the soul. Bosch never rendered human physiognomies with a more intense ugliness, and it has been thought that he was inspired here by Leonardo's more or less contemporaneous drawings of grotesque heads. It is also conceivable, however, that he was absorbing stimuli from German art,

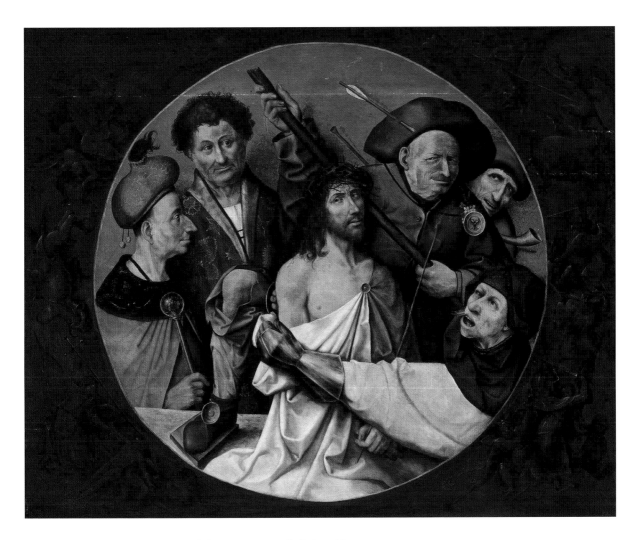

which for generations had endowed the tormentors of Christ with monstrously deformed features.

In this maelstrom of evil, the heads of Christ and Veronica appear oddly calm and aloof. Eyes closed, they seem focused within, undisturbed by the tumult around them; Veronica's lips even wear a hint of a smile. Paradoxically, it is Christ's image imprinted on her veil that looks out to us beseechingly. The contrast between Christ himself and the two thieves could not be greater. The bad thief, in the lower right-hand corner, snarls back at his taunting captors; the good thief above appears about to collapse in terror at the words of his diabolic confessor. Both thieves are still trapped in the tumult of this world, but Christ has withdrawn to a higher sphere where his persecutors cannot reach him. In the midst of suffering, he is victorious. And to all who take up his Cross and follow him, Christ promises the same victory over the World and the Flesh: this was the message which Bosch's half-length Passion scenes commended to his contemporaries.

Bosch or follower of Bosch
Christ Crowned with Thorns, before 1511 (if autograph) or after 1533
Oil on panel, 165 x 195 cm
El Escorial, Monasterio de San Lorenzo

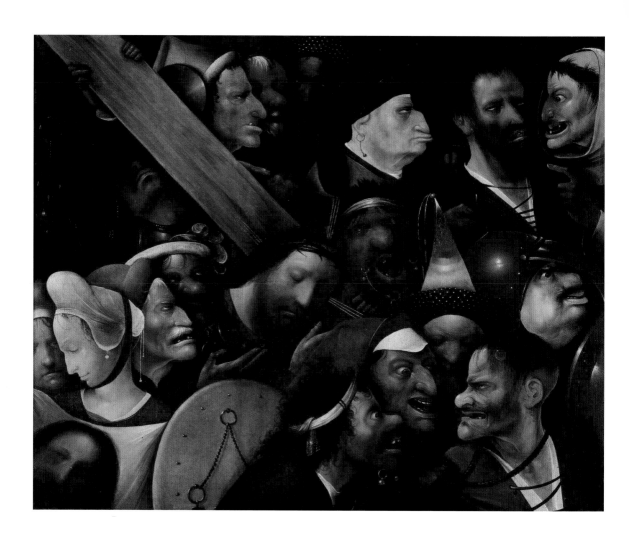

The Triumph of the Saint

In his pictures of the saints, Bosch seldom depicted those miraculous exploits and spectacular martyrdoms that so fascinated the later Middle Ages. One exception is the Venice *Crucifixion of a Female Martyr* (p. 84), whose dating remains the subject of much controversy. On each of the two wings of this triptych, Bosch had originally painted a kneeling donor. For reasons unknown, however, he then replaced these with *St Anthony in Meditation* on the left and the *Two Slave Dealers,* who sold St Julia to Eusebius (as these two figures are usually interpreted), on the right. Since the triptych is documented in Italy in the early sixteenth century, it was assumed that the altarpiece had been commissioned by Italian patrons and took as its central theme the Crucifixion of St Julia, also known as St Liberata, a saint whose cult was particularly strong in Italy. In the meantime, however, a number of specialists have voiced the not unfounded opinion that the subject of the central panel is St Wilgefortis, also known as St Uncumber. This latter miraculously grew a beard in order to escape marriage to a heathen, whereupon her own father had her crucified. Even though the female figure in Bosch's panel does not display any beard hair, this does not completely rule out the possibility of her identification with Wilgefortis. Yet another puzzle set by Bosch for modern scholarship to solve, in other words!

With the exception of this Crucifixion scene, Bosch's other paintings of saints otherwise focused upon the more passive virtues of the contemplative life and their endangerment by the temptations of this world: no soldier saints, no tender virgins defending their chastity right up to their final breath, but hermits meditating quietly in a landscape.
Three variations of this theme appear in the Venice triptych of the *Hermit Saints,* today sadly damaged (the panels originally rose up to an arch). Whether Bosch conceived the triptych as an altarpiece must remain open, in view of the modest dimensions of the work. In the central panel (p. 80), St Jerome meditates in front of a Crucifix, amidst the scattered remains of a pagan temple. The scene as a whole finds its prelude in the deadly fight between two monstrous animals on the strip of earth in the immediate foreground. On the left wing, St Anthony the Hermit resists the amorous advances of the Devil-Queen, an episode to which we shall return. In a cave chapel on the right-hand wing, St Giles prays for the safety of his companion and nourisher, the hind lying at his feet; the arrow piercing his breast had been intended for her.
All three saints embody the monastic ideal as set forth, for example, in the *Imitation of Christ*: a life spent in mortification of the flesh and in continuous prayer and meditation. In the *St Jerome at Prayer* (p. 83) today housed in Ghent, Bosch formulates an even more telling image of this ideal. Jerome has

Bosch school
Temptation of St Anthony, 2nd half of the 16th century (?)
Pen and bistre, 25.7 x 17.5 cm
Berlin, Kupferstichkabinett SMPK

PAGE 78:
Christ Carrying the Cross, c. 1510 (?)
Oil on panel, 76.7 x 83.5 cm
Ghent, Musée des Beaux-Arts

cast himself down, a Crucifix cradled in his arms; his splendid red cardinal's robe lies abandoned on the ground. Absent are the dramatic gestures – the breast-beating and the eyes raised adoringly to the Cross – with which other artists represented the penitent saint, but in this still, intent figure, Bosch has nonetheless poignantly conveyed Jerome's spiritual process. The peaceful background panorama contains no hint of evil, but the swampy grotto in which the saint lies is rank with corruption and decay. In his autobiography, the church father notes that his meditations in the wilderness were frequently interrupted by apparitions of beautiful courtesans. These lustful monstrosities are probably symbolized by the large decomposing fruits near the saint's cave, reminiscent of the flora in the *Garden of Earthly Delights*. Only by surrendering completely to the will of God could Jerome subdue his rebellious flesh.

In another picture Bosch shows St John the Baptist reclining beside a rock slab in a wonderfully atmospheric summer landscape (p. 85). In its organic embedding of the protagonist within an idyllic landscape, the composition may well have been influenced by the painting *St John the Baptist in the Wilderness* (Berlin, Gemäldegalerie SMPK) completed some years earlier by Geertgen tot Sint Jans. Whereas Geertgen represented the last prophet of the Old Covenant staring abstractedly into space, rubbing one foot against the other, Bosch shows him pointing purposefully towards the Lamb of God crouching in the lower right-hand corner. This gesture traditionally identifies John the Baptist as the forerunner of Christ, the *precursor Christi*. In this instance, however, it also indicates a spiritual alternative to the life of the flesh that is symbolized in the great pulpy fruits hanging near the saint on gracefully curving stems, and in the equally ominous forms rising in the background.

A landscape similarly charged with evil appears in a painting housed in Rotterdam (p. 87), in which the giant Christopher staggers across the river, his red cloak bunched up behind him and carrying the Christ Child on his back. According to legend, the later St Christopher had started out as heathen giant who had first served a king and then the Devil himself in his search for a powerful and worthy master – a search that ended only when a hermit converted him to Christianity. The hermit stands at the edge of the water in the lower right-hand corner; his treehouse has been transformed into a broken jug, which houses a devilish tavern. Above, a naked figure scrambles up the highest branch towards a beehive, which may be understood as a symbol of drunkenness. Across the river, a dragon emerges from a ruin, frightening a swimmer, while a town blazes in the shadowy distance.

No less secure against the wiles of the Devil is *St John the Evangelist* in a painting in Berlin (p. 89). The youthful apostle is depicted on the island of Patmos, to which he had been banished by the Emperor Domitian and where he composed the Book of Revelation, here seen lying open on his lap. His mild gaze is lifted towards an apparition of the Virgin enthroned on a crescent moon, the Apocalyptic woman described in Revelation 12:1–16. The saint's attention has been directed to the vision by an angel whose slender figure and delicately plumed wings appear scarcely more substantial than the misty Dutch panorama behind. Perhaps influenced by earlier representations of this subject, Bosch has for once restrained his usual predilection for demonic spectacles. There are, to be sure, several ships burning in the water

St Anthony
St Giles
Left and right wings of the *Hermit Saints*
triptych, c. 1493 or later
Oil on panel, 86.5 x 29 cm (each)
Venice, Palazzo Ducale

St Jerome
Central panel of the *Hermit Saints* triptych,
c. 1493 or later
Oil on panel, 86.5 x 60 cm
Venice, Palazzo Ducale

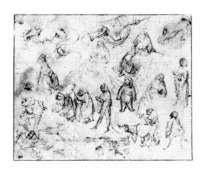

Workshop
Studies for the *Temptation of St Anthony*
Pen and bistre, 20.5 x 26.3 cm
Paris, Musée du Louvre, Cabinet des Dessins

in the lower left-hand corner, and a little monster can be seen lower right, both details probably suggested by St John's Apocalypse, but neither seriously disturbs the idyllic landscape in which the saint contemplates his inner visions.

But the evil still held in check on the front of the Berlin panel bursts out all the more furiously in the figures of monsters on the grisaille reverse (p. 88). The Passion of Christ, culminating at the top in the Crucifixion, unfolds within the outer ring of the medallion. The Mount of Golgotha is repeated symbolically in the inner circle, namely in the high rock surmounted by a pelican in her nest. A traditional symbol of Christ's sacrifice, the pelican – so it was claimed in one of the most widely read medieval bestiaries, itself based on writings from late Antiquity – fed her young with blood pricked from her own breast. It is appropriate, therefore, that she should appear on the back of a panel devoted to St John, the beloved disciple who had himself rested his head, as Dante tells us (*Paradiso*, XXV), on the breast of the Divine Pelican.

It is likely that the small pictures of saints discussed above were intended to be contemplated in the quiet of the cloister or private chapel. They present, in terms of the monastic ideal, the arduous path that the Christian pilgrim must climb to regain his lost homeland and achieve union with God. Nowhere, however, were the vicissitudes of the spiritual life more vividly and circumstantially detailed than in the legend of St Anthony the Hermit, founder of Christian monasticism, which Bosch painted on an altarpiece now preserved in Lisbon.

The motif of St Anthony is one that Bosch and his workshop frequently explored in paintings and drawings. A small panel in the Prado, visualizing the saint meditating in a sunny landscape (p. 90), is also generally attributed to Bosch. Without a doubt, however, the Lisbon triptych of the *Temptation of St Anthony* (pp. 91–95) remains Bosch's most comprehensive and differentiated treatment of the theme.

When St Anthony, who passed most of his long life (c. 251–356) in the Egyptian desert, was one day praying in the shelter of an old tomb, he was overwhelmed by a horde of devils who almost beat him to death. The devils later attacked him a second time in the same spot, this time tossing him high into the air, before being driven away by a Divine light. Satan then appeared to the hermit in the guise of a beautiful and saintly queen whom Anthony encountered bathing in a river. Taking the hermit into her city, the Devil-Queen showed him all her supposed works of charity, and it was only when she sought to seduce the bedazzled Anthony that he recognized her true nature and intentions.

Two of these episodes are represented on the left-hand inner wing of the Lisbon altarpiece. In the foreground, the unconscious Anthony is being carried across a bridge by two companions dressed in the habit of the Antonite Order, accompanied by a figure in secular dress, possibly a self-portrait of the artist. Anthony appears simultaneously in the sky, borne aloft by demons, his hands clasped in desperate prayer as monsters buzz around him like angry insects. Three more monsters confer beneath the bridge as an equally grotesque messenger skates towards them on the ice. In the middle ground, a kneeling giant presents his bare buttocks; the entrance to the brothel lies between his open thighs. A false beacon lures ships on the distant

St Jerome at Prayer, c. 1482 or later
Oil on panel, 77 x 59 cm
Ghent, Musée des Beaux-Arts

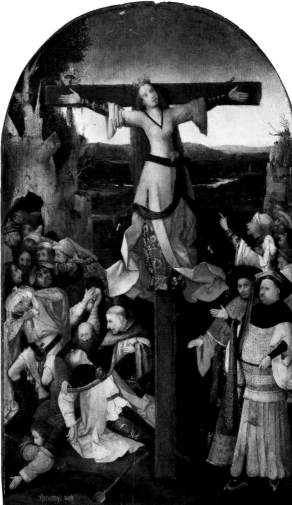

Altarpiece with the *Crucifixion of a Female Martyr* (triptych), c. 1497 or later
Oil on panel, 104 x 119 cm
Venice, Palazzo Ducale

LEFT WING:
St Anthony in Meditation
Oil on panel, 104 x 28 cm

CENTRAL PANEL:
Crucifixion of a Female Martyr (St Julia?)
Oil on panel, 104 x 63 cm

RIGHT WING:
Two Slave Dealers
Oil on panel, 104 x 28 cm

PAGE 85:
St John the Baptist in the Wilderness, 1489 or later
Oil on panel, 48.5 x 40 cm
Madrid, Museo Lazaro Galdiano

sea to their destruction, as gruesomely documented by the corpses that litter the shore.

On the right-hand wing, Bosch takes as his starting point the motif of the Devil-Queen. Standing in the waters flowing sluggishly past the hermit, surrounded by her infernal court, she offers him a glimpse of her dazzling naked body. Anthony averts his eyes from this obscene group only to be summoned by a demon-herald to the devilish feast in the foreground. The open-air table, the cloth slung tent-like over the tree stump beside the temptress and the servants pouring wine seem like a grotesque parody of the traditional Garden of Love. In the background looms the city of the Devil-Queen: a dragon swims in the moat and flames erupt from the top of the main gate.

In the middle panel, monstrosities of all kinds are arriving by land, water and air from all four points of the compass, and not least from the burning village in the left-hand background, to converge upon a ruined tomb in the centre. On a platform before the tomb, an elegantly dressed couple are offering

Bosch or his workshop
Two Witches
Pen and bistre, 12 x 8.5 cm
Rotterdam, Museum Boijmans Van Beuningen

St Christopher Carrying the Christ Child,
1498–1510 (?)
Oil on panel, 113 x 71.5 cm
Rotterdam, Museum Boijmans Van Beuningen

drinks to a bizarre group of companions. Nearby, a similarly nobly clad woman in a large headdress and a gown with an extravagantly long train kneels at a parapet to offer a drinking-bowl to a figure opposite. Kneeling beside her, almost unnoticed in the midst of this hellish activity, is St Anthony himself; he turns towards the viewer, his right hand raised in blessing. His gesture is echoed by Christ, half hidden in the depths of the tomb, which Anthony has converted into a chapel. The outside of the building is covered with monochrome murals, amongst which the Adoration of the Golden Calf and a group of men making offerings to an enthroned ape exemplify the degenerate nature of all idolatry. The representation of the Israelites returning from Canaan with an enormous bunch of grapes prefigures Christ carrying the Cross on the outer wings of the triptych.

The devils who have gathered around St Anthony exhibit a hallucinatory formal potency and metamorphotic creativity. In the group on the far right of the tower, for example, a blasted tree trunk becomes the bonnet, torso and arms of a woman whose body terminates in a scaly lizard tail; she holds a baby and is mounted on a giant rat (p. 95). Nearby, a jug has been transformed into another beast of burden, whose wholly unsubstantial rider bears a thistle for a head. In the water below, a man has been absorbed into the interior of a gondola-fish, his hands thrust helplessly through its sides. In the lower left-hand corner, an armoured demon with a horse's skull for a head plays a lute; he sits astride a plucked goose who is wearing shoes and whose neck ends in a sheep's muzzle. All these shifting forms display a richness of colour that confers the aesthetic of ugliness upon even the most repugnant shape. A recent, careful cleaning of the triptych, among Bosch's best preserved works, has revealed brilliant reds and greens alternating with subtly modulated passages of blue-greys and browns.

According to the saint's legend, this convocation of fiends must represent the second attack on Anthony: the miraculous light that dispersed the devils on this occasion can be seen shining through one of the chapel windows. Like the monstrous creatures who confront Deguileville's pilgrim, the satanic beings and apparitions represented in this picture are probably incarnations of the sinful urges with which Anthony wrestled in his desert solitude. Bax and other scholars believe they can identify a number of the sins symbolized by Bosch's monsters, whereby a leading role is played by Lust. In the present wing, too, Lust displays its power in undisguised fashion in the group of buildings in the right-hand background, where a monk and a prostitute drink together within a tent; the dark-skinned devil in the central group may also be a demon of Lust.

Anthony, however, has triumphed over all his temptations through the strength of his faith. This victorious faith is expressed in his gesture of benediction, thought to be particularly efficacious against the Devil. The steady gaze with which the hermit fixes the viewer, moreover, may be understood as one of comforting assurance: "Though an army may encamp against me, my heart shall not fear" (Psalms 27:3). It is the same gaze with which Christ looks out at us from the Madrid *Christ Carrying the Cross* and the London *Christ Mocked*.

According to Jacobus de Voragine in the *Golden Legend*, a compendium of lives of the saints first published in the thirteenth century, when Anthony recognized the presence of Christ in the miraculous light, he cried out:

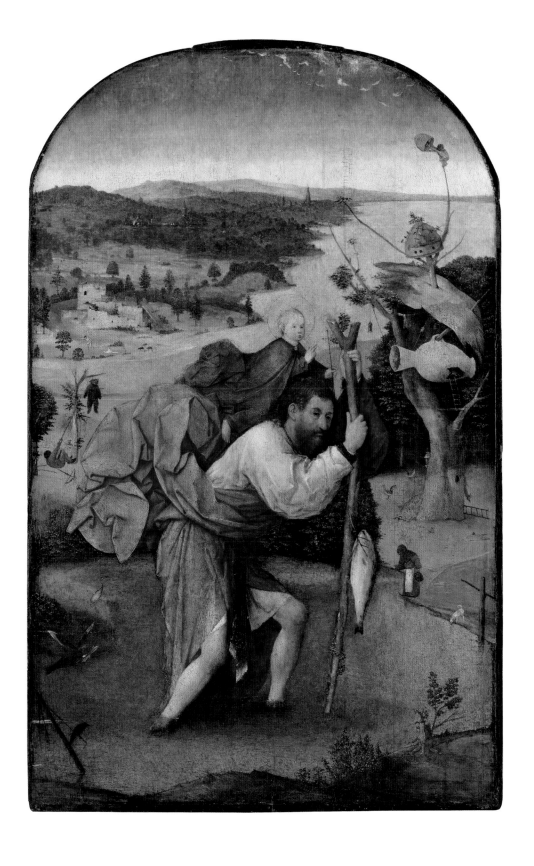

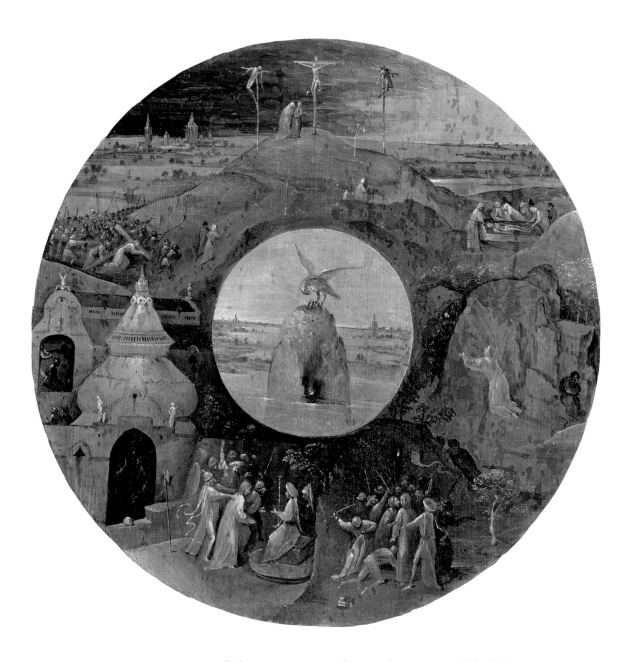

"Where were you, o good Jesus, where were you? Why did you not come sooner to help me and heal my wounds?" To which Christ replied, "Anthony, I was here, but I waited to see how you would fight. Now, because you fought manfully, I shall make your name known all over the earth." While the wings of the Lisbon triptych show Anthony tempted and tormented, the central panel thus shows him triumphant.

This last-mentioned aspect of the central panel casts light on a frequently misunderstood aspect of Bosch's art. In representing Anthony and other saints tormented and tempted by the Devil, Bosch was not giving expression to a Zoroastrian dualism, as some scholars have suggested. He did not view

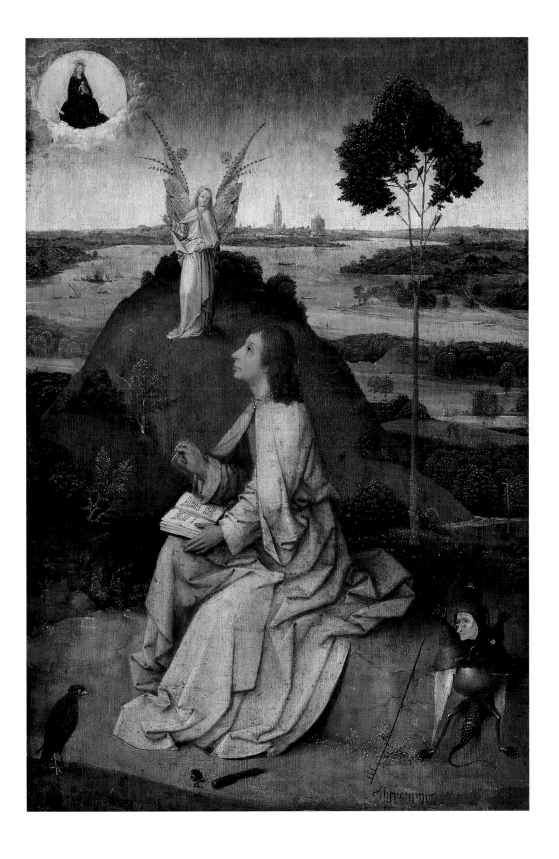

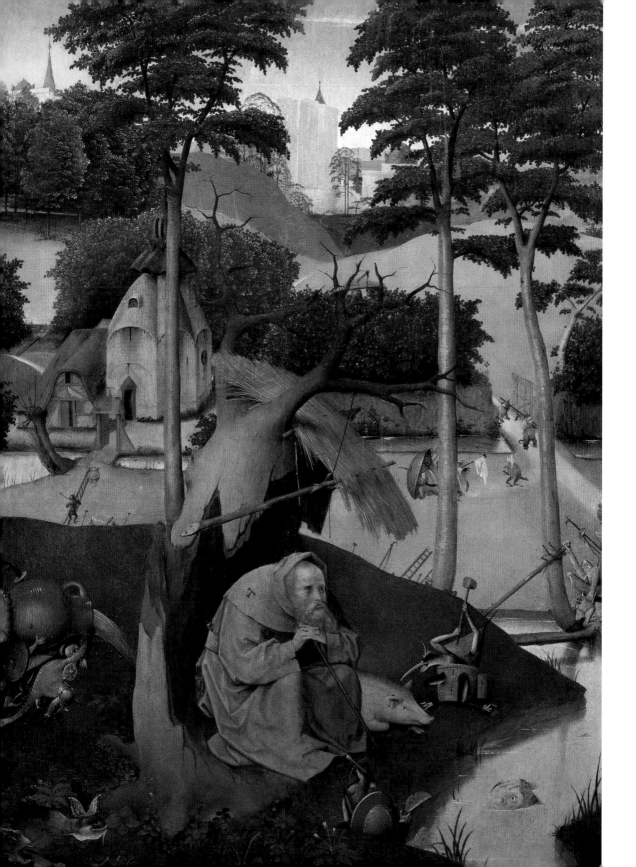

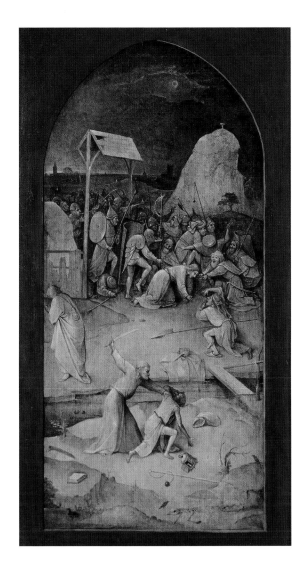
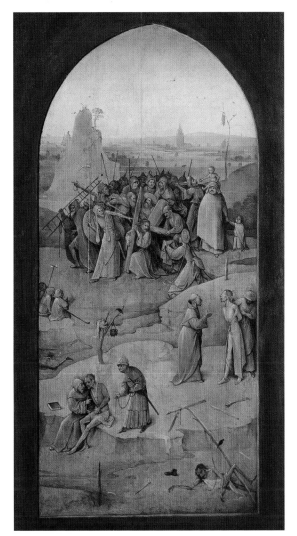

the world as a stage upon which was enacted the struggle between equally powerful forces of good and evil, for this would have denied the omnipotence of God. On the contrary, Bosch and his contemporaries knew that God permitted Satan to send tribulations to men for the good of their souls. God allows the Devil to attack the saints, explains St Augustine, "so that by outward temptation they may grow in grace" (*City of God*, xx, 8). In his voluntary submission to these troubles, the man of God achieves the most perfect imitation of Christ.

It is most appropriate, therefore, that Anthony's sufferings should be echoed on the exterior of the same altarpiece in two grisaille scenes from Christ's Passion (above). On the left, soldiers overwhelm Christ in the Garden of Gethsemane as viciously as the devils attack Anthony on the other, inner side, while Judas hurriedly steals away with his traitor's reward of thirty pieces of silver. In the right-hand panel, Christ's collapse beneath the weight of his Cross has halted the procession to Golgotha, allowing St

Temptation of St Anthony
Outer wings of the triptych
Grisaille on panel, 131 x 53 cm
Lisbon, Museu Nacional de Arte Antiga

LEFT OUTER WING:
Arrest of Christ in the Garden of Gethsemane

RIGHT OUTER WING:
Christ Carrying the Cross

PAGE 90:
Bosch or follower of Bosch
Temptation of St Anthony, 1500/25
Oil on panel, 70 x 51 cm
Madrid, Museo del Prado

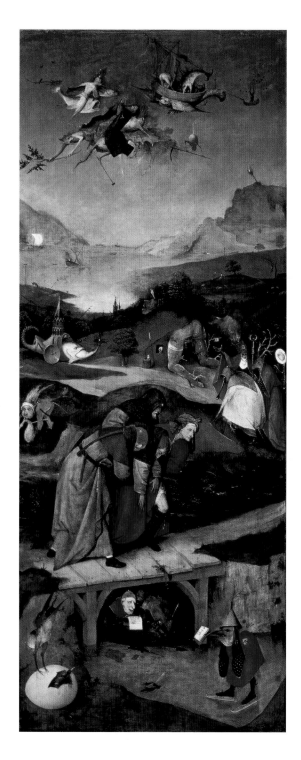

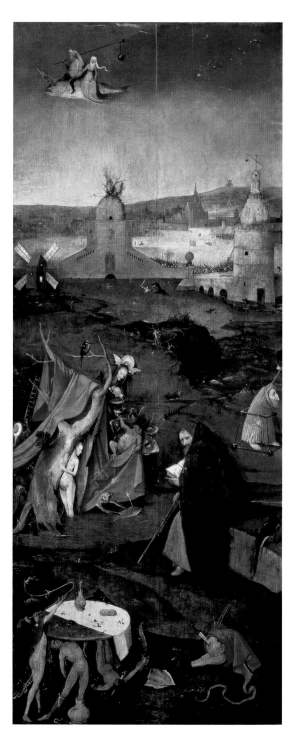

Temptation of St Anthony (triptych), c. 1501 or
later
Oil on panel, 131.1 x 225 cm
Lisbon, Museu Nacional de Arte Antiga

Flight and Failure of St Anthony
Oil on panel, 131.5 x 53 cm

St Anthony in Meditation
Oil on panel, 131.5 x 53 cm

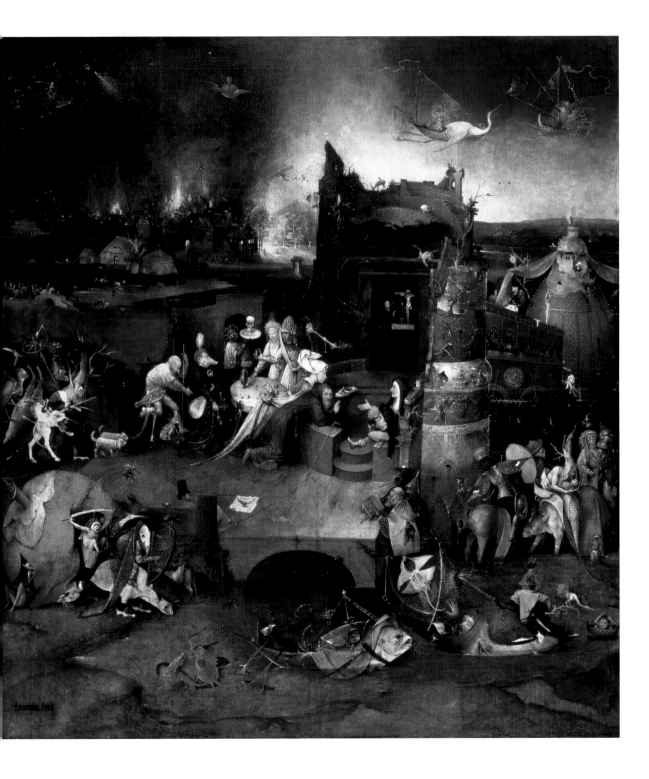

CENTRAL PANEL:
Temptation of St Anthony
Oil on panel, 131.5 x 119 cm

PAGES 94–95:
Demon-Priest and Monsters
Detail of the central panel

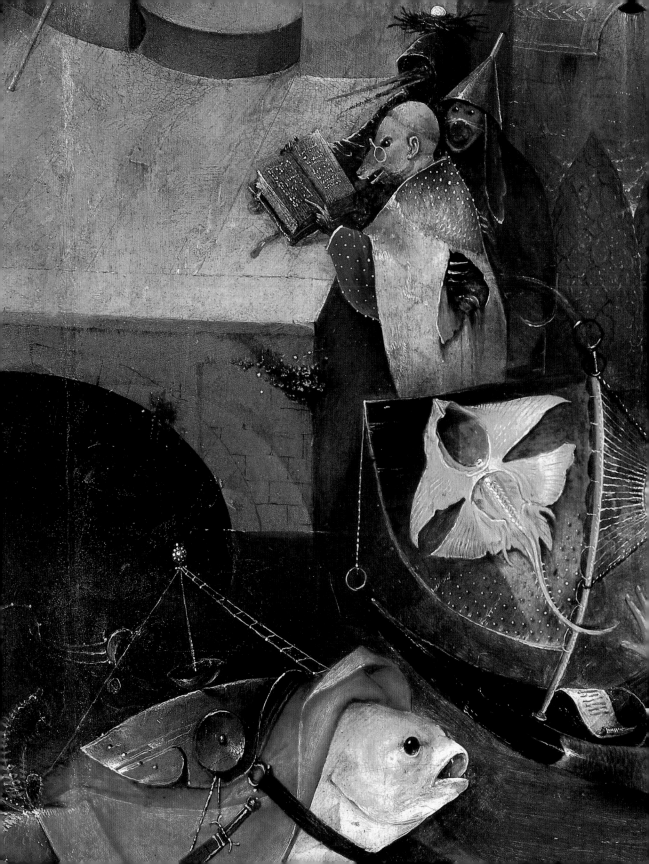

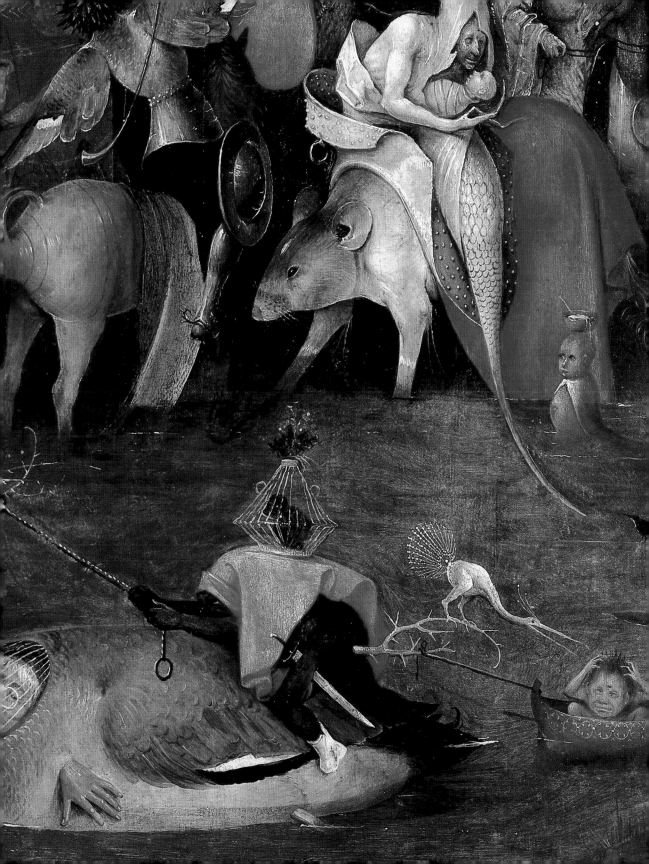

Veronica to wipe the sweat from the Saviour's face. The executioners can hardly restrain their impatience at this delay, and the bystanders look on more with idle curiosity than with sympathy. Below, the two thieves confess to hooded friars whose disreputable characters have been deftly portrayed.

The Lisbon triptych thus sums up the major themes we have encountered in the art of Bosch. The spectacle of sin and folly and the shifting horrors of Hell are joined to the images of the suffering Christ and of the saint firm in his faith against the assaults of the World, the Flesh and the Devil. To an age that believed in the reality of Satan and Hell, and was convinced that the appearance of the Antichrist followed by the Last Judgement would occur with absolute certainty in the near or more distant future, the serene countenance of the demon-plagued St Anthony must have offered reassurance and hope.

Yet, even as Bosch painted the Lisbon triptych, men were questioning the values for which St Anthony stood, particularly the cloistered life spent in solitude away from one's fellow men. Erasmus and other humanists were already teaching that a Christian individual should furnish proof of his faith not outside the world but within it, through honest conduct and honest labour. And in 1517, only one year after Bosch's death, Luther nailed his ninety-five theses to the door of a Wittenberg church and thereby initiated the events that completely disrupted the old order. Like Luther, Bosch frequently castigated the corruption of the clergy and the monks – but this was an old complaint. There is hardly anything to be detected in Bosch's oeuvre that might equate to a radical rejection of the medieval Church. The figures that he created with such inexhaustible imagination departed from the established bounds of convention, but without truly breaking with the most important traditions of the Christian faith. The criticism that the artist directed at ecclesiastical and social institutions echoed the general desire for reform and was not a pre-Reformation call to arms. Bosch's art formulated a glorious statement of the "autumn of the Middle Ages" and at the same time – in some of its innovations – offered a glimmer of the coming epoch, the era of humanism at the dawn of the Renaissance.